The artist is always at the margin. Nothing creative ever happens at the center. The artist revels in the disequilibrium of things; art emerges out of a disequilibrium in search of a new equilibrium. The creative act itself is the emergence of something new. That is why it is so important to create. Monet's impressionistic art was something new. He blurred the outlines and expressed something that couldn't be expressed any other way.

Artists have something in them that is wild, something that is guided and inspired ultimately by imagination. The universe from the beginning has been poised between the expanding and the containing forces, and no one knows if this creative balance will collapse or will continue indefinitely.

- Thomas Berry, author, historian, Roman Catholic Priest (HERON DANCE interview, Issue 21, June 1999)

. . . every poet, every artist is an anti-social being. He's not that way because he wants to be; he can't be any other way. Of course the state has the right to chase him away . . . and if he is really an artist it is in his nature not to want to be admitted, because if he is admitted it can only mean he is doing something which is understood, approved, and therefore old hat — worthless. Anything new, anything worth doing, can't be recognized. People just don't have that much vision. So this business about defending and freeing culture is absurd.

- Pablo Picasso

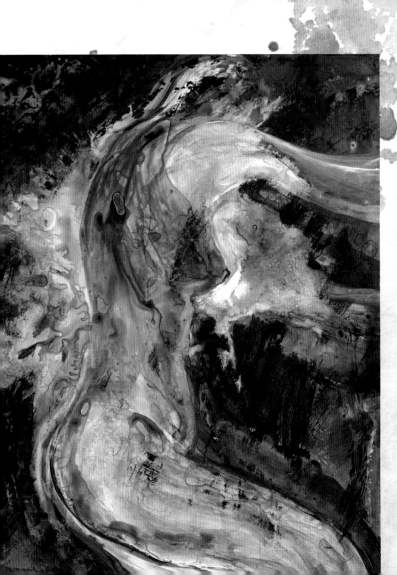

Painting: Evolutionary Dance

1

HERON DANCE PRESS & ART STUDIO

Hummingbird Lane
179 Rotax Road
N. Ferrisburgh, VT 05473
888-304-3766
www.herondance.org

Printed on Recycled Paper in the United States by HGI (Inland Graphics) in Menomonee Falls, WI.

Heron Dance donates art to dozens of grassroots wilderness protection groups each year.
In addition, *Heron Dance* supports the Northeast Wilderness Trust with financial donations.
For more information, please contact our office at 888-304-3766.

ISBN-13: 978-1-933937-42-7

The art throughout is by Roderick MacIver (www.herondance.org).

Painting: Kestrel in Blue

RECYCLED PAPER

2

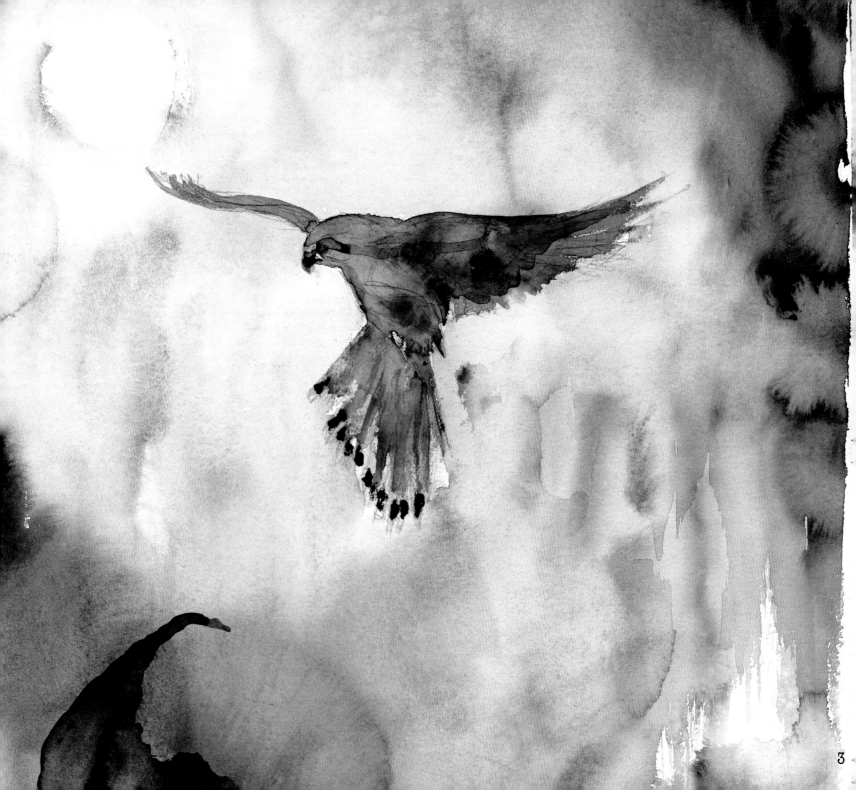

3

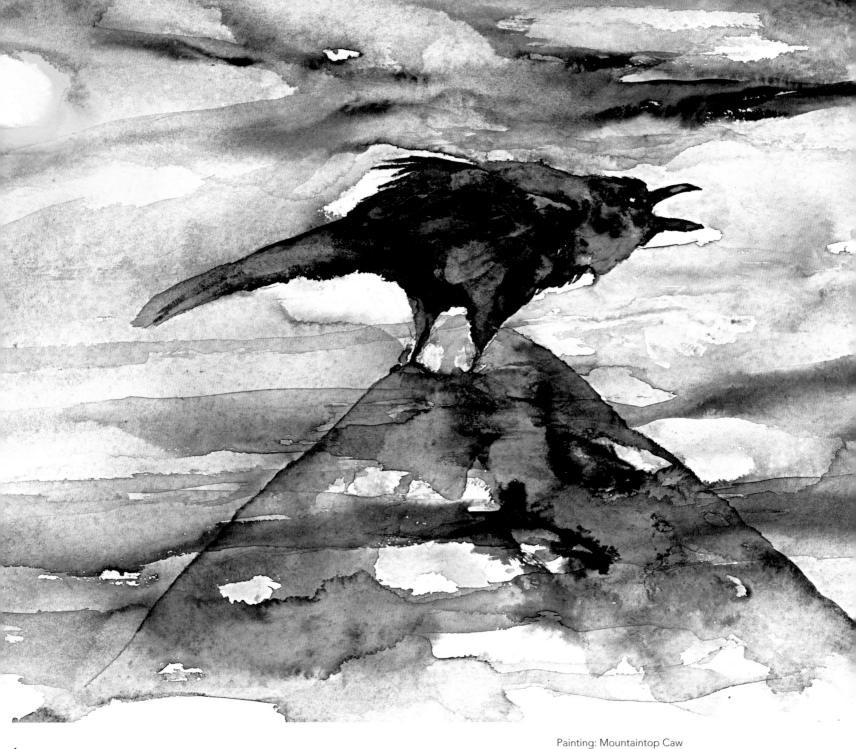

Painting: Mountaintop Caw

HERON DANCE

Subscriptions, Art
(888) 304-3766

Office, Studio
(802) 922-9652

E-mail
heron@herondance.org

Website
www.herondance.org

Founder, Author, Artist
Roderick W. MacIver

Business Manager
Gina Tindall

Copy Editors
Celeste DiFelici
Beverly Hilliard

HERON DANCE
Hummingbird Lane
179 Rotax Road
North Ferrisburgh, VT
05473

·

Cover Art:
Spring Arrival

RECYCLED
PAPER

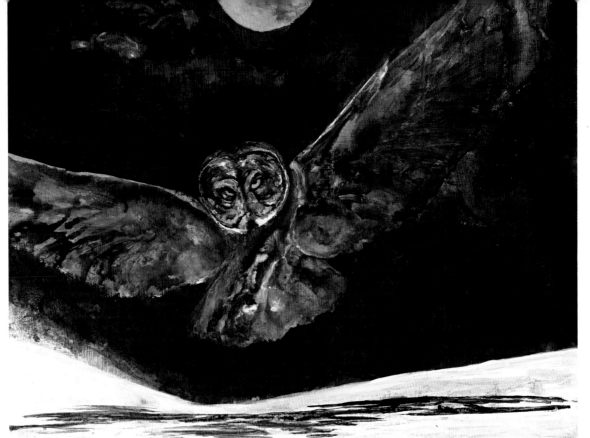

Painting: Evening At The Meadow

Contents:

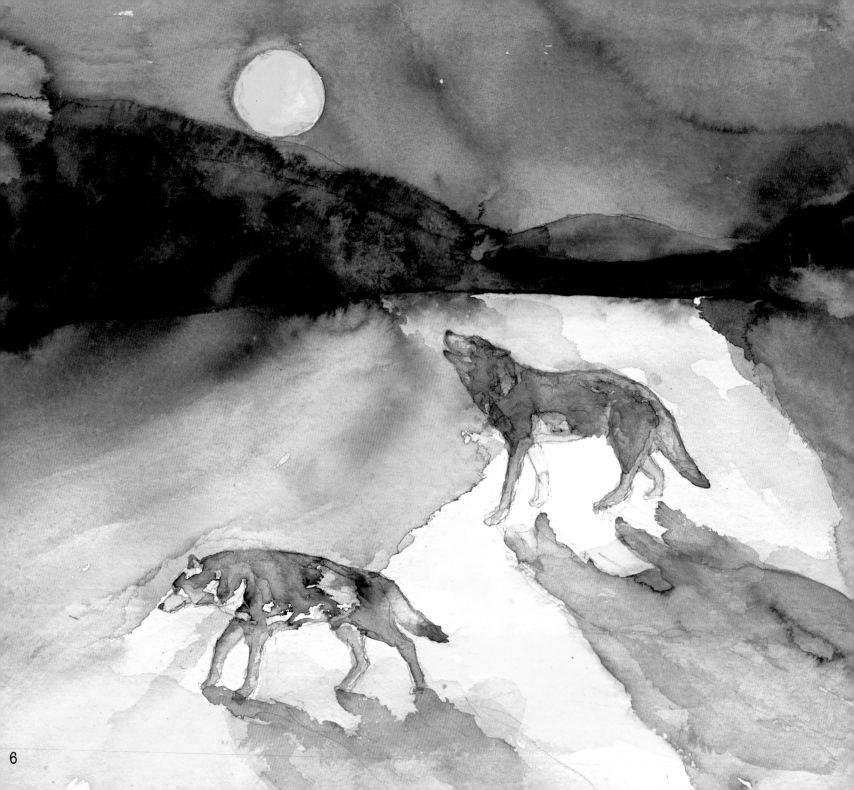

Introduction

Resides there, at the edge of the human enclosure, artists whose purpose it is to explore the edge, the border territory, of what it means to be human. They work in territory where one reality encounters another, where light encounters dark, where scariness and beauty mingle, where demons and gods dance. There, vague sensations are encountered that can often only be sensed on some kind of preverbal basis. They explore their interior world, they explore the mystery of existence, of nature. They do what they do based on some combination of imagination, hard work and discipline. They search for truth and find part-truth. Many of those in this group are not particularly nice, not particularly respectable. To do what they do, it helps to not be overly concerned about what others think.

Change happens at the edges, at the margin. Artists like things a little unsettled, a little out of whack. That's where new forms, new ways of thinking, emerge. Artists, whether they paint nature or not, paint that which is wild, free, unrestrained. Human society is about rules and conformity and security — the spirit-killing search for safety and comfort.

> There are two kinds of truth, small truth and great truth. You can recognize a small truth because its opposite is a falsehood. The opposite of a great truth is another great truth.
> - Niels Bohr (1885-1962), recipient of the 1922 Nobel Prize for Physics

> The small truth has words that are clear;
> the great truth has great silence.
> - Rabindranath Tagore

The opposite of a great truth is another great truth. Great truth has great silence. At the center of science, of art and music, of life, is a mystery. That mystery is the territory of the artist, however misguided, screwed up he or she may be.

Painting: 'Twas the Night Before Christmas

7

The human activates the most profound dimension of the universe itself, its capacity to reflect on and celebrate itself in conscious self-awareness. When we in turn create art, it is not purely out of ourselves, but out of a continuation of the creativity of the universe.

- Thomas Berry, author, *Dream of the Earth*, (HERON DANCE interview, Issue 21, June 1999)

When humans contemplate the universe, they represent, in a way, the universe contemplating itself. Made up of elements of the universe, the human mind reflects back on the nature of the universe, and then, in its own way, creates, just as the universe is itself a dynamic, expanding entity structured in a way that new life forms, new solar systems, emerge and die off. Art — music, images, poetry, fiction — is the human response to the mystery of being an entity on this planet, in this universe, living in the flow. The mystery is both the mystery of the universe and the mystery within one's self.

Years ago I interviewed artist Frederick Franck, artist and author of *Zen and the Art of Seeing* among other books. He gave me a pamphlet he had written about Pacem in Terris, the sculpture gardens he and his wife Claske created. The gardens, he said, are "a sacred place that speaks to the sacred space at the core of the human heart." In the pamphlet I came across this quote:

Art is not a luxury! Art arises from one's depths or it is not art but kitsch! Art, for me, is and was my digging tool for Meaning, for Truth . . . my own truth that may speak to your truth. Art then becomes a "religious," a spiritual act, not in any sectarian sense but as a witness to a "religious" attitude to sheer being, to existence as such, being Supremely Meaningful.

Art is a tool of exploration, a digging tool. The urge behind that digging arises out of a compulsion to come to terms with or honor or understand something deep in the human experience. Or maybe in the universe. Despite our science, and all of our technology, sits there still the mystery, calmly licking its chops.

Penetrating so many secrets, we cease to believe in the unknowable. But there it sits, nevertheless, calmly licking its chops.

- H.L. Mencken

If it was easy to express the meaning of the mystery through art there would be no point to art, or at least art would lack power. The artist who embarks on that journey is honoring something that is asking for a voice. That voice led Mozart to write music and Picasso to paint.

At the center of human existence are difficult trade-off: freedom versus security, the role of beauty and harmony, and the price of those things. Truth. A substantial portion of human activity is designed to avoid truth, protect us from the truth. Truth is scary. When confronting truth, we are all inadequate. Art searches for truth and finds part-truths. Artists stand in opposition to institutions that perpetuate feel-good false-hoods. Through creativity, humanity evolves.

> Everything that is beautiful is orderly, and there can be no order unless things are in their right relation to each other. Of this right relation throughout the world beauty is born.
> - Robert Henri, *The Art Spirit*

I do art to express the profound peace I've sometimes experienced in wild nature. For me, wild nature includes both wilderness lakes and nudes. (A nude model smiling at me! She seems to be enjoying herself, but maybe that smile can't be counted on. Maybe she's mocking me and my lecherous ways. Maybe. Oh well, it can't be helped.) There have been times, particularly on canoe trips, when I've experienced a feeling so lovely, so deep, so in harmony with the beauty around me, that sound seemed to stop and the world move in slow motion. I try to serve those few experiences with my art, to explore them, revel in them, to welcome them into my interior life and give them a home. My art nurtures that.

For thirty-five years, I've kept journals of successes and failures and lessons learned. In them I put art that captures my imagination, poetry, song lyrics and writing that have enriched my life. This book, which is also part of a subscription to the (newly renamed) *Heron Dance Creativity Journal,* is based on excerpts on the creative process that I've found most inspiring, most challenging and most helpful over the last fifteen years.

Journal Notes

January 1

Man does indeed know intuitively more than he rationally understands. The question, however, is how we can gain access to the potentials of knowledge contained in the depth of us, how we can achieve increased capacities of direct intuition and enlarged awareness.
- *At a Journal Workshop* by Ira Progoff

January 4

One's art goes as far and as deep as one's love goes, and there is no reason for painting but that.
- Andrew Wyeth

Art seems to me to be a state of soul more than anything else. The soul of all is sacred.
- Marc Chagall

Art is like love in the sense that to love, one needs to work on oneself. Love is the manifestation of inner harmony and beauty. Art is a manifestation of inner work too and of the discipline required to penetrate one's self.

January 10

The creative life is a search for freedom — freedom for the wild entity inside that wants to sing. An artist, a writer, a musician, seeks to give that song a life of its own. To set it free so that it can make its own way in the world.

Painting: Winter Fun

We seek to free ourselves of self-imposed limitations.

> I rejoice that horses and steers have to be broken before they can be made the slaves of men, and that men themselves have some wild oats still to sow before they become submissive members of society. Undoubtedly all men are not equally fit subjects for civilization; and because the majority, like dogs and sheep, are tame by inherited disposition, this is no reason why the others should have their natures broken that they may be reduced to the same level. Men are in the main alike, but they were made several in order that they might be various. If a low use is to be served, one man will do quite as well as another; if a high one, individual excellence is to be regarded. Any man can stop a hole to keep the wind away.
> - Henry David Thoreau, *Walking*

January 12

The epigraph to James Joyce's *Portrait of the Artist as a Young Man* came originally from a description of Daedalus in *Metamorphoses*.

> *. . . et ignotas animum dimittit in artes naturamque nouat.*
> "And he sets his mind to unknown arts and changes the laws of nature."

Those words, written in 8 A.D., suggest that by practicing the unknown arts — the arts of mystery — the artist causes change, even imbalance. *Metamorphoses* was a narrative poem written by Ovid (P. Ovidius Naso) and is fifteen books long. It influenced many works of literature that followed through the centuries, including Chaucer's *Canterbury Tales* and Shakespeare's *Romeo and Juliet, A Midsummer Night's Dream* and *The Tempest*.

In *Metamorphoses*, Daedalus, father of Icarus, was a craftsman, artisan and builder of labyrinths — labyrinths used by the king to imprison those he didn't like. Daedalus was locked up in a tower so that others would not learn the labyrinth's escape routes. He constructed

Painting: Hawk Owl Landing

wings of wax and feathers (the unknown arts?) so that he and his son Icarus could escape. Icarus, caught up in the thrill of flying, flew too close to the sun; the wax melted, and he disappeared into the sea.

The story has been compared by some, including Joseph Campbell, to an escape from the Wasteland by following one's bliss. The Wasteland is that place where people live repetitive, empty lives in the pursuit of security. They avoid risk but waste away their lives. When you turn your back on the Call, life turns its back on you.

The spiritual journey of following one's bliss requires humility. Disaster awaits those who fly too close to the sun.

January 16

Your dance grows out of your stillpoint. Before work, an artist needs to make contact. Contact! Make contact with the mysterious, powerful entities that underlie existence, whatever you perceive them to be.

> Except for the point, the stillpoint,
> There would be no dance,
> And there is only the dance.
> - T.S. Eliot

Painting: Midnight At Big Trout Lake

I sit in silence. I try to tune into my inner world. I try to tune into something or Something larger. These rhythms that I feel — where are they from? From inside? From the Greater Rhythms of Being-ness? Of the universe?

If your canoe tips over in a wild rapid a hundred miles from the nearest road, and your food and gear have just disappeared around the bend, first get dry. Then sit down and get a hold on yourself. Tune in to your resourcefulness. An artist needs to believe in her resourcefulness. An artist needs to believe in the value of his creative journey.

Seventeen years ago I was diagnosed with advanced cancer of the lymph nodes. Every day, I sat in silence and I told myself, over and over, in a silent chant, "I am a survivor." I believe today that meditation played a crucial role in my recovery. It guided me through the mine fields of alternative and conventional treatments.

Before starting work, I try to become receptive to whatever intuition or messages might come my way from whatever entities might exist outside or inside. I tune in to my belief in myself. I try to open myself up to visions that cannot be expressed in words — the vague sensations. When beginning a work of art, find that state of relaxed awareness. Try to sense where the work, which is to have a life of its own, wants to go.

Relax into an awareness that your creativity comes from somewhere deep, somewhere not knowable.

> I stand in awe of my body, this matter to which I am bound has become so strange to me. I fear not spirits, ghosts, of which I am one — that my body might — but I fear bodies, I tremble to meet them. What is this Titan that has taken possession of me? Talk of mysteries! — Think of our life in nature — daily to be shown matter, to come in contact with it — rocks, trees, wind on our cheeks! the solid earth! the actual world! the common sense! Contact! Contact! Who are we? where are we?
> - Thoreau, The Maine Woods, *Ktaadu* (1848)

I always get up and make a cup of coffee while it is still dark — it must be dark — and then I

drink the coffee and watch the light come. . . . Writers all devise ways to approach that place where they expect to make the contact, where they become the conduit, or where they engage in this mysterious process. For me, light is the signal in the transition. It's not being in the light, it's being there before it arrives. It enables me, in some sense.
- Toni Morrison

January 17

Before work, give quiet thanks. Show humility, be respectful. We are courting the unknown, and asking it for its indulgence, its favor.

The most beautiful thing we can experience is the mysterious; it is the source of all true art and science.
- Albert Einstein

January 18

There's not much difference between a voodoo king and a blues poet. So says Tony Moffeit, blues poet of Pueblo, Colorado. As artists, we're in search of the secret energies in the universe. Those energies are wild, wild can't be fenced in, understood.

Walking down Bourbon Street I noticed a huge sign: Chickenman's House of Voodoo. I walked inside. A young woman asked me if she could help me. I told her, "I'm looking for voodoo." She replied, "You came to the right place. This is the Chickenman's House of Voodoo." I asked, "Who is the Chickenman?" She answered, "My God, man, you don't know who the Chickenman is? He's only the oldest and the greatest of the Voodoo Kings."
　　I asked if I could meet the Chickenman. She said, "Of course," and went to the back room to get the voodoo king. Chickenman emerged in all his splendor: wearing a big hat of chicken feathers that was covered in magical charms. He looked at me with blazing black eyes and

exclaimed, "I'm Chickenman. Prince Keeyama. The Voodoo King of New Orleans. The people of the city gave me that name." I replied, "Hello, Chickenman. I'm Tony Moffeit. Blues Poet of Pueblo, Colorado. The people of the city gave me that name." And bang! There was an immediate meeting of minds. Because there's not much difference between a voodoo king and a blues poet. Both are looking for those secret energies in the universe. Externally, the poet is no different from anyone else. Internally, he is a revolutionary. Internally, he is a creator of new laws, his own laws. Internally, he is an outlaw. . . .

The process is this: 1. The artist must tap into the ghost energy. This can be done in a number of ways. You can listen to a moody song. Or a rhythmic song. Or a ballad. You can read poems that touch the phantom language. You can turn off the lights. Sometimes, you don't have to do anything. Somehow, you need to get in touch with the spirits. 2. You must allow the ghost energy to let

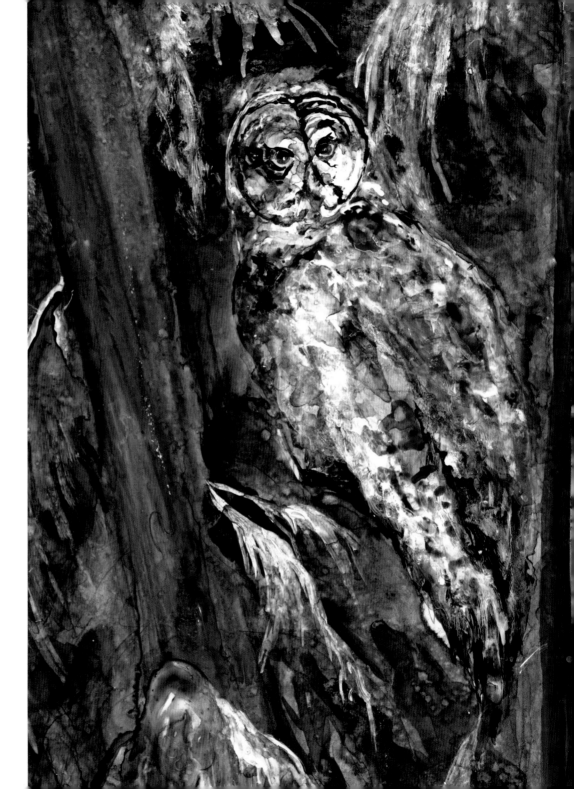

Painting: Owl Woods, Winter Evening

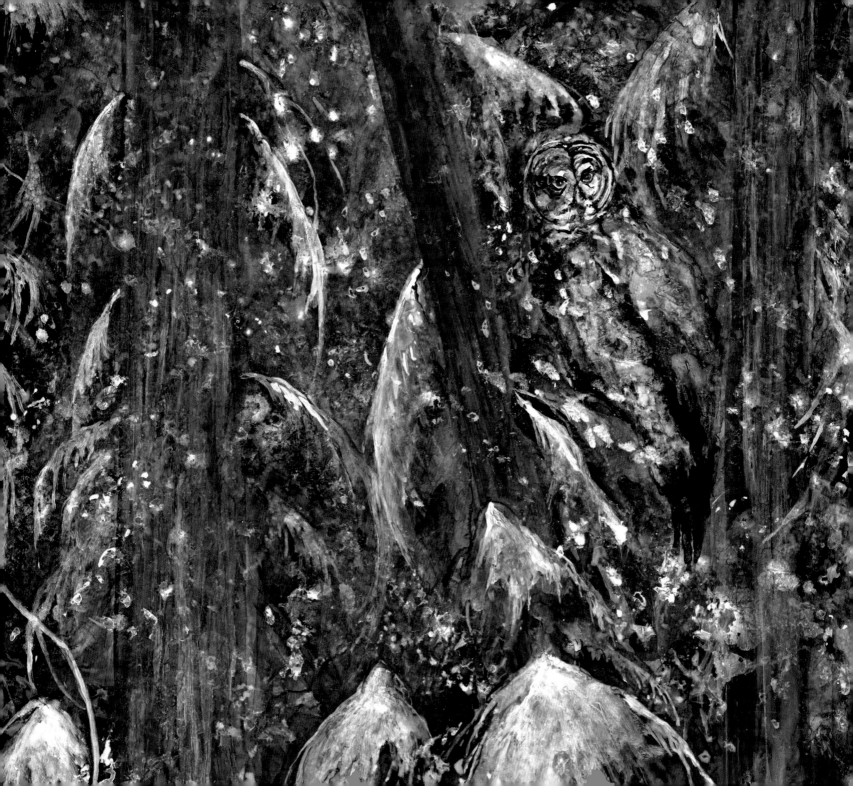

you work on many levels, many dimensions. You must see the mystical in the physical, the spiritual in the object, the passionate in detachment. You must reach a point of connecting with everything and being able to turn your poem inside out. You must stretch the language, reach another dimension. And you must do this without pretense. You must do this with the simplicity of language, reaching the most complex ideas with a simple but evocative language. 3. You must reach a point where you sing. Where the language takes over and sings you. The individual becomes universal.

My favorite poets are the outcasts, the outlaws, the supreme individualists, the passionate singers, the loners, the lovers. Ikkyu, the great Japanese Zen poet, Walt Whitman, the solitary singer. Art lives in a ghost world, a phantom world, a world in which the artist is a law unto oneself. Awards and rewards are good. They help with the external. But, really, the true poet is about the internal. It has very little to do with educators and the government. It has to do with the spirit of the individual artist. That spirit can conquer anything. That spirit can overcome anything. The internal world of the poet is superior to the external world. The internal world of the poet is phenomenal. About the only thing you compare it to is love. It is a love affair with life. It is experiencing miracles on a daily basis. It's not that educators and the government are bad. They serve their purpose. It's just that they are superfluous in comparison with the individual spirit, the creative will of the artist.

What do I think about the current rise of interest in poetry? I think, as always, the rise of interest in poetry produces fewer poets. Poets appear when there is an atmosphere of desperation. Poets appear out of the wasteland. Poets appear in outlaw territory.

- Tony Moffeit, from "Examining the Process of Creating," an interview from *The Lummox Journal*, September 2000. (www.lummoxpress.com)

January 19

It is what is left over when everything explainable has been explained

Painting on Previous Pages: Owl Woods, Winter Evening

that makes a story worth writing and reading. The writer's gaze has to extend beyond the surface, beyond mere problems, until it touches that realm of mystery which is the concern of prophets. . . .

 If a writer believes that the life of a man is and will remain essentially mysterious, what he sees on the surface, or what he understands, will be of interest to him only as it leads him into the experience of mystery itself.
 - Flannery O'Connor, from "Literary Witch," *Colorado Quarterly* (Spring 1962)

January 20

Yes, the artist's role is to work in the land of mystery where things aren't clear, but however uncertain an artist is, the work needs to be executed with conviction, with certainty. Wishy-washy, cautiousness, makes for weak art.

 A wor k of art which inspires us comes from no quibbling or uncertain man. It is the manifest of a very positive nature in great enjoyment, and at the very moment the work is done.
 - Robert Henri, *The Art Spirit*

Conviction takes courage. We need to assert our vision, even if we're just as uncertain and scared as the next person.

 The outward work will never be puny if the inward work is great.
 - Meister Eckhart

January 23

In his autobiography *Chronicles One*, Bob Dylan talks about stumbling across the song "Pirate Jen-

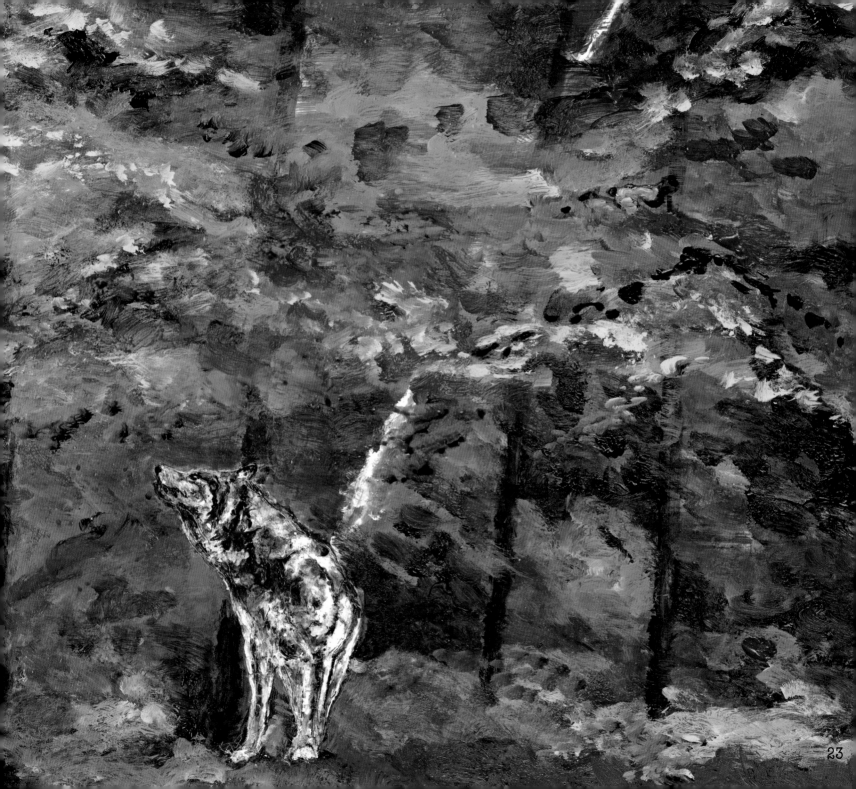

23

ny" from *The Threepenny Opera* by Bertolt Brecht and Kurt Weill. It changed his relationship with his art. Within a few minutes, he felt that he "hadn't slept or tasted food for about thirty hours. I was so into it. . . .This was a wild song. Big medicine in the lyrics. Heavy action spread out. Each phrase comes at you from a ten-foot drop, scuttles across the road and then another one comes like a punch on the chin. And then there's always that ghost chorus about the black ship that steps in, fences it all off and locks it up tighter than a drum. It's a nasty song sung by an evil fiend, and when she's done singing, there's not a word to say. It leaves you breathless."

> You gentlemen can say, "Hey gal, finish them floors!"
> Get upstairs! What's wrong with you! Earn your keep here!
> You toss me your tips
> and look out to the ships
> But I'm counting your heads
> as I'm making the beds
> Cuz there's nobody gonna sleep here, honey
> Nobody! Nobody!
> Then one night there's a scream in the night
> And you say, "Who's that kicking up a row?"
> And ya see me kinda starin' out the winda
> And you say, "What's she got to stare at now?"
> I'll tell ya.
>
> There's a ship, the black freighter
> turns around in the harbor
> shootin' guns from her bow . . .
> - from "Pirate Jenny," lyrics: Bertolt Brecht/Marc Blitzstein, melody: Kurt Weill

Dylan writes about taking the song apart, trying to find out what made it tick. The song reminded him of Picasso's painting *Guernica*. "This heavy song was a new stimulant for my senses, indeed very much like a folk song but a folk song from a different gallon jug in a different backyard. . . .I took the song apart and unzipped it — it was the form, the free verse association, the structure and disregard for the known certainty of melodic patterns to make it seriously matter, give it its cutting edge."

Painting on Previous Pages: Owl Woods, Winter Evening II

As he studied the song, he decided that what he really wanted to sing were songs that didn't exist — songs that transcended the information in them, the character and the plot. He needed to write his own songs. The first efforts were rough, didn't quite work. He kept trying. Dylan met John Hammond, legendary talent scout for Columbia Records, a short while later, and Hammond gave Dylan a record by an obscure bluesman, Robert Johnson. Again, Dylan studied the music.

> Over the next few weeks I listened to it repeatedly, cut after cut, one song after another, sitting staring at the record player. Whenever I did, it felt like a ghost had come into the room, a fearsome apparition. The songs were layered with a startling economy of lines. . . . I copied Johnson's words down on scraps of paper so I could more closely examine the lyrics and patterns, the construction of his old-style lines and the free association that he used, the sparkling allegories, big-ass truths wrapped in the hard shell of nonsensical abstraction — themes that flew through the air with the greatest of ease. I didn't have any of these dreams or thoughts but I was going to acquire them.

Painting: Kestrel Woods

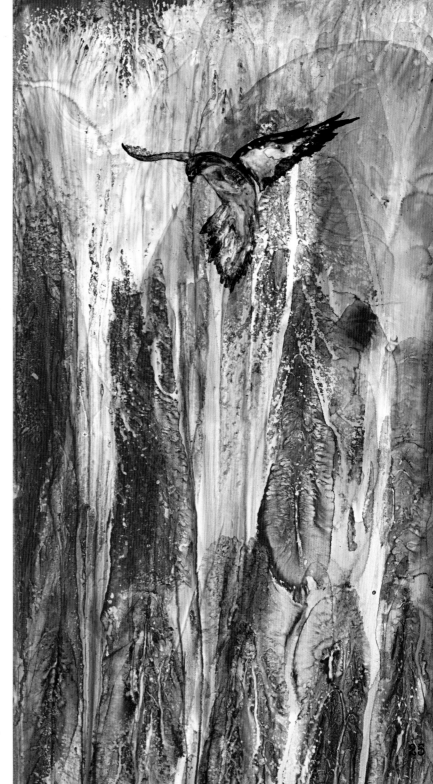

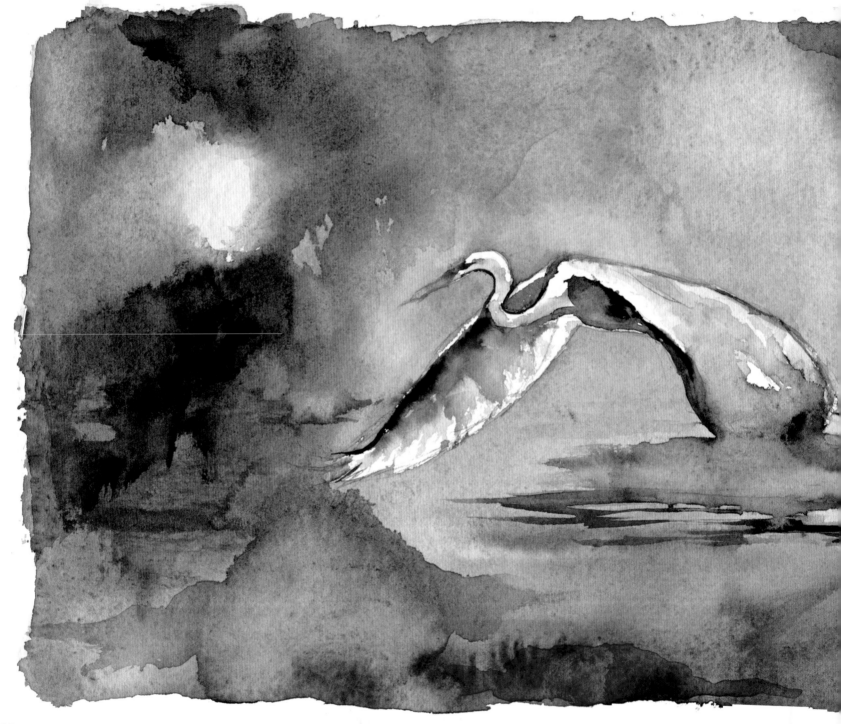

Painting: Purple Harmony

John Hammond told me that he thought that Johnson had read Walt Whitman . . . I couldn't imagine how Johnson's mind could go in and out of so many places. He seems to know about everything, he even throws in Confucius-like sayings whenever it suits him. As great as the greats were, he goes one step further. You can't imagine him singing, "Washington's a bourgeois town." He wouldn't have noticed and if he did, it would have been irrelevant.

In a few years' time, I'd write songs like "It's Alright Ma (I'm Only Bleeding)," "Mr. Tambourine Man," "Lonesome Death of Hattie Carroll," "Who Killed Davey Moore," "Only a Pawn in Their Game," "A Hard Rain's Gonna Fall" and some others like that. If I hadn't gone to the Theatre de Lys and heard the ballad "Pirate Jenny," it might not have dawned on me to write them, that songs like these could be written. In about 1964 and '65, I probably used about five or six of Robert Johnson's blues song forms, too, unconsciously, but more on the lyrical imagery side of things. If I hadn't heard the Robert Johnson record when I did, there probably would have been hundreds of lines of mine that would have been shut down — that I wouldn't have felt free enough or upraised enough to write . . . Everything was in transition and I was standing in the doorway. Soon I'd step in heavy loaded, fully alive and revved up. Not quite yet though.

January 25

After writing his own folk music for a while, Bob Dylan, folk musician, became Bob Dylan, folk rock musician. He went electric and crowds booed. They came to hear the Dylan they knew, the Dylan whose albums they owned. He dismissed them. He'd stand up in front of booing crowds and say things like, "I don't believe you," and then he'd play his music. Sometimes he did an entire performance with his back to the crowd.

In a 1966 *Playboy* interview, Dylan said:

I was doing fine, you know, singing and playing my guitar. It was a sure thing,

don't you understand, it was a sure thing. I was getting very bored with that. I couldn't go out and play like that. I was thinking of quitting. Out front it was a sure thing. I knew what the audience was gonna do, how they would react. It was very automatic. Your mind just drifts unless you can find some way to get in there and remain totally there. It's so much of a fight remaining totally there all by yourself. It takes too much. I'm not ready to cut that much out of my life. You can't have nobody around. You can't be bothered with anybody else's world. . . . They can boo till the end of time. I know that the music is real, more real than the boos.

In May 1963, Dylan was invited to perform on *The Ed Sullivan Show*, the leading entertainment program on television at the time. It was a major career opportunity. He planned to perform his new song, "Talkin' John Birch Paranoid Blues." CBS's lawyers nixed the selection, telling him that the song was too controversial and potentially libelous. They suggested he play "Blowin' in the Wind." Instead, Dylan decided not to perform at all.

I salute his faith in his music and his rejection of the limitations others wanted to impose on his work. Dylan may have an unusual, even odd singing voice — as, by the way, did Billie Holiday — and his lyrics may sometimes be impossible to decipher, but he had the courage of his artistic vision. There is something special there, something deep. Just as Dylan's understanding of the potential of his art opened up after hearing "Pirate Jenny" and the music of Robert Johnson, Dylan has given folk and rock musicians an enlarged understanding of the potential of their art. I once heard a rock star say that Dylan opened a door for all musicians into a new landscape. If they chose to step through it.

Dylan told *Playboy* interviewer Nat Hentoff:

The pressures were unbelievable. They were just something you can't imagine unless you go through them yourself. It was important for me to come to the bottom of this legend thing, which has no reality at all. What's important isn't the legend, but the art, the work. . . .Happiness is not on my list of priorities. For some reason, I am attracted to self-destruction.

February 15

The grinding of light and dark throws off big sparks. Artists explore the territory where light and dark meet, where gods and demons dance. If they report back in a profound way, they often get paid big bucks and, by and large, forgiven for their trespasses. Hence Picasso, Miles Davis, Keith Richards, John Lennon, Bob Dylan, Jack Kerouac, Janis Joplin, etc.

Many great artists are profoundly troubled. Some self-destruct. But out of disequilibrium can emerge new insights, new ways of seeing. Sometimes new beauty emerges.

I once heard a biographer of Miles Davis interviewed on the radio, and he was asked something like: "How could a guy who was apparently so selfish and unkind to so many people, who could be such a son of a bitch to 99 percent of the people he had contact with, play such soft and beautiful music?" The biographer answered, "He played music like the person he wanted to be."

Here's an excerpt from Jack Chambers's introduction to his book *Milestones: The Music and Times of Miles Davis:*

> It was as though, when he emerged into the daylight after those years behind drawn shades, he had lost track of who he used to be.
> Five or six years of cocaine at $500 a day, along with an uninterrupted routine of what he called "kinky sex and other weird shit," might have killed enough brain cells for that loss of identity — as his son Gregory charged in his lawsuit. It might even have turned the Prince of Darkness into "Duffy Davis." That was what he told Eric Nisenson he wanted to be called. ... Nisenson met Davis in his retirement years and, to his surprise, found himself admitted into Davis's darkened brownstone, where used syringes crackled underfoot and television sets flickered in the corners. Davis vaguely promised Nisenson that he would collaborate with him on his biography. The price Nisenson paid was exacted in whispered phone calls at all hours of the night or day telling him to deliver six-packs of Heineken, groceries, Band-Aids, cough

Painting: A Celebration of Hawkdom

drops and, before long, plain brown envelopes from coke dealers. Nisenson came to think of his role as "indentured servitude." He hated it and eventually cooled on the friendship, but not before becoming privy to Davis's bouts of shadow-skulking paranoia, some ferocious beatings of his young girlfriend, and his pathetic pleas for late-nigh succor. . . . *The Autobiography of Miles Davis* is a self-portrait of a sleaze ball.

The most original parts of the *Autobiography* are the wacky, outrageously frank anecdotes. Davis always claimed he was brutally honest. In the *Autobiography* the emphasis is on brutality. Davis ponders the sexual proclivities of his high school sweetheart and the paternity of two of his three children by her, eventually disowning one and keeping the others. He calmly recounts how he destroyed the dancing career of his first wife, Frances, when his fits of jealousy and suspicion confined her to the kitchen while he was out romping. He calls his second wife, Betty Mabry, "a high-class groupie," and boasts about committing adultery on his third wife, Cicely Tyson, five days after their wedding. He harps about his dissolute eldest sons, who lived with him through his own most dissolute years. He reminisces about extorting money from the French actress Juliette Greco, pawning Clark Terry's trumpet and clothes to buy heroin, firing Vincent Wilburn (who "felt . . . like he was my own son") immediately before the concert in Wilburn's home city, and vomiting on the ambassador in the reception line on his first visit to Japan. He talks matter-of-factly about beating all his wives and several girlfriends. "I just slapped the shit out of her," he says of Tyson. Oddly enough, his boasts about slapping women around overlook two women who had the nerve to press charges: Lita Merker, who charged him with unlawful imprisonment in 1972 and Aida Chapman, who charged him with assault in 1984. He indulges in diatribes on classical music ("robot shit" in his view), race, sex objects, police, and orgasm.

This is self-inflicted tabloid journalism.

John Lennon, the Beatle who wrote "Give Peace a Chance" and "Imagine," beat his wives and girl-friends. David Comfort in his book about the lives of prominent rock stars (*The Rock and Roll Book of the Dead*) offers some perspective on rock musicians living at the edge:

Many of the stars buried themselves in their frenetic touring schedules since, in their quieter moments of self-reflection, they often tended to surrender to depression, self-loathing and

suicidal thoughts. Occasionally, they succeeded in digging themselves out of these valleys but, as time passed, more often they drugged themselves deeper in.

"I'm a very nervous person, really," said Lennon. "I'm so nervous," said Elvis. "I've always been nervous, ever since I was a kid." A boyhood friend described him as "squirrelier than a yard dog." Cobain called himself a "neurasthenic" and "twitchy." Morrison regularly told his band members he was having a "nervous breakdown." Janis had hers when she was seventeen, and Lennon his after the Beatles' breakup. As children, most had suffered insomnia, anxiety attacks, and terrifying nightmares. Later, as much as they loved the spotlight, all but a few had major stage fright.

"I was just a weird, psychotic kid covering up my insecurity with a macho façade," Lennon confessed. But even as an adult, the psycho kid inside often got the best of the Clever One, especially when he was under the influence of the devil's dandruff and Brandy Alexanders. During his "lost weekend" in LA, he heckled the Smothers Brothers onstage, crowing "Fuck a cow!" He called Yoko "a
slant-eyed bitch," and his in-laws "gooks." When performing in Hamburg, wearing a toilet seat around his neck, he cackled, "Hey remember the war? We fuckin' won!" then grabbed his crotch and goose-stepped the stage, crowing 'Sieg Heil THIS!"

For me, it was never really an "act," those so-called performances. It was a life and death thing.
 - Jim Morrison, lead singer of The Doors

In addition to all the guitars and hotel suites he smashed up, Hendrix totaled six Corvettes in two years. . . . Janis's Porsche Cabriolet Super C with its psychedelic painting job "was her pride and joy," remembered her producer, Paul Rothschild. "We both had Porches. We'd race along Sunset Boulevard and Laurel Canyon. She was a

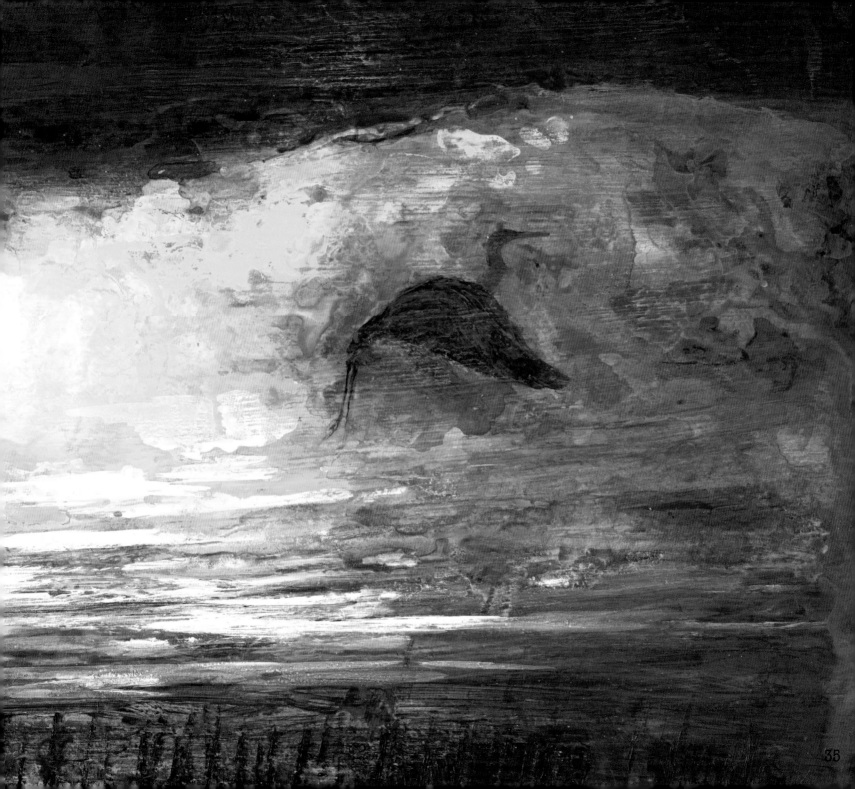

lot crazier than I was — and I was nuts. She'd go against traffic on blind curves, with the top down, laughing, "Nothing can knock me down."

I'm not that bad a driver, and I get in a wreck almost every day.
 - Kurt Cobain, lead singer and guitarist of Nirvana

It's a downer, this stuff. It's sad. The question is are they great artists because of this darkness or despite it. Some say despite. Some say the darkness is irrelevant. All that matters is the art, they say. In the context of art, they say a miserable person who does great work is more important than a nice person who creates weak art.

I think the darkness contributes. Somehow, an element in an artist's life that is very dark and heavy and sad contributes depth.

And then there is Frédéric Back (creator of the film *The Man Who Planted Trees*). He is a quiet, humble man, a man of dignity and great artistic talent. He restores one's faith in the innate goodness of which people in general and artists in particular are capable. Of course, he's got high standards. When he was making films, he tried working with a number of assistants'. Over time, he gave up and drew the sometimes tens of thousands of images his films required himself. As far as darkness is concerned, there is a lot of it in his background. He grew up on the border of France and Germany between two world wars. He was fifteen, I think, when the Nazis bombed and then marched through. He saw a lot of suffering by both people and animals. Perhaps the darkness of that period accounts in part for the power of his art.

February 20

The writer's only responsibility is to his art. He will be completely ruthless if he is a good one. He has a dream. It anguishes him so much that he can't get rid of it. He has no peace until then. Everything goes by the board: honor, pride, decency, security, happiness, all, to get the book written. If a writer has to rob his mother, he will not hesitate; the "Ode on a Grecian

Painting on Previous Pages: Lake of Ghosts

Urn" is worth any number of old ladies.
 - William Faulkner, *Paris Review* interview (1958)

March 1

I went off with fists in my torn pockets;
My coat was completely threadbare.
I followed you, Muse, where you led me,
Dreamed of loves — ah — so fine and so rare.
 - Rimbaud, *Ma Bohéme*

Rimbaud has been an inspirational figure to many artists, and at least one politician. I first became aware of the quote above via the then Prime Minister of Canada, Pierre Elliot Trudeau, who offered it in his retirement speech at the Liberal Party Leadership Convention in 1984. You don't hear many U.S. politicians quoting Rimbaud (he was gay, and kind of unruly, undependable and self-obsessed from all accounts), although his work inspired both Picasso and Jim Morrison. Henry Miller wrote a book about Rimbaud's influence on his life and work, *The Time of the Assassins.*

Here's a quote from a letter Rimbaud wrote to his friend Izambard:

Now I am going in for debauch. Why? I want to be a poet, and I am working to make myself a visionary: you won't possibly understand, and I don't know how to explain it to you. To arrive at the unknown through the disordering of all the senses, that's the point. The sufferings will be tremendous, but one must be strong, be born a poet: it is in no way my fault. It is wrong to say: I think. One should say: I am thought. Pardon the pun.

I is some one else. So much the worse for the wood that discovers it's a violin, and to hell with the heedless who cavil about something they know nothing about!

The young Rimbaud signed his letters "The Heartless Rimbaud."

March 2

> Don't worry about rejection. Everybody that's good has gone through
> it. Don't let it matter if your works are not "accepted" at once. The bet-
> ter or more personal you are the less likely they are of acceptance.
> - Robert Henri, *The Art Spirit*

When work is rejected, an artist needs to think through whether it was because he or she didn't probe deep enough, avoided territory that was scary, that might offend, or because the work probed too deep, because it alienated those concerned about protecting their comfort zone, them that lives in the straight and narrow, who want to be reassured that they made the right decision by avoiding risk in life, by avoiding the juice of life. As an artist, you've got to accept that them that dwells in the Wasteland is not gonna like ya.

> In every work of genius we recognize our own rejected thoughts.
> - Ralph Waldo Emerson

The art genius has the courage of his or her conviction. Art geniuses work at their craft out of a compelling need to express something. They take the same thoughts as you and me, but they act on them. The genius was as much in their courage and discipline as their intellect.

Genius believes in the power of dreams, in the interior world, in the mystery of the universe.

> In every madman is a misunderstood genius.
> - Antonin Artaud

Or is it that every misunderstood genius is a madman, a man who didn't care much what others thought? He (or she) was in search of deeper truths.

March 19

The connection with our creativity, with the "song within," needs to be nurtured. It's tenuous. All kinds of things affect it. Nurturing your creative life requires self-love, not in an arrogant way but in a gentle, humble way. It is a process of discipline, and discipline is closely related to self-love, to a belief in oneself. Nurturing our creative life requires that we open our eyes and our souls and see the beauty around us. We can't allow the struggles, setbacks and discouragements to shut beauty out of our awareness. The process must be gentle because the song within is shy and retreats in the face of harshness, whether the harshness is that of the larger world or the harshness that we sometimes impose upon our own selves.

When we start out as artists, we have the energy of our message. We're righteous. We're self-disciplined. We live close to our song, in harmony with it. Over time reality bangs up against us just as it does against everything. Art is activity in a resistant medium.

> Activity in war is movement in a resistant medium.
> - *Clauswitz on War*, Karl von Clausewitz

Okay, life is an activity in a resistant medium, but art, real art, is an activity in a very resistant medium.

Maybe we run out of money a few times, and it wears us down. Or maybe we make lots of money and that causes us to lose touch with our art. Maybe we work too hard and get worn out. Some of the greatest albums in rock history have been recorded in a week by musicians in their late teens and early twenties. Ten or even five years later, it can take them months to turn out a mediocre product. Drugs, exhausting performance schedules and wealth make the excitement that was there in the beginning a vague memory.

> "You think you're semi-divine when you're in the limo, and semi-divine
> at the hotel, until you're semi-divine for the whole goddamn tour," said
> Keith Richards, looking back on the exodus of Brian Jones from The

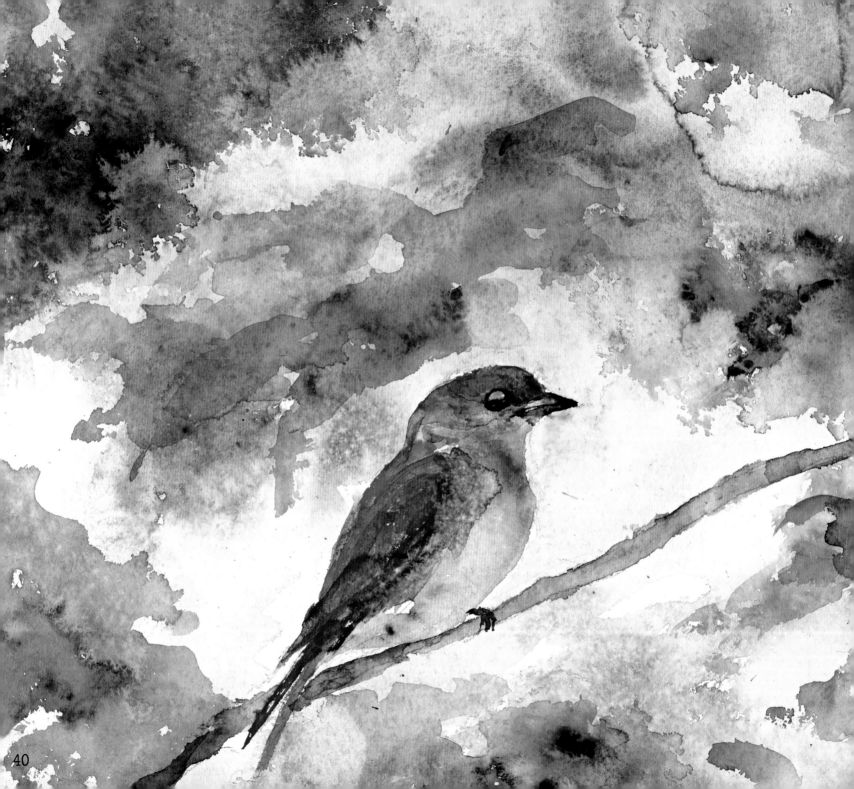

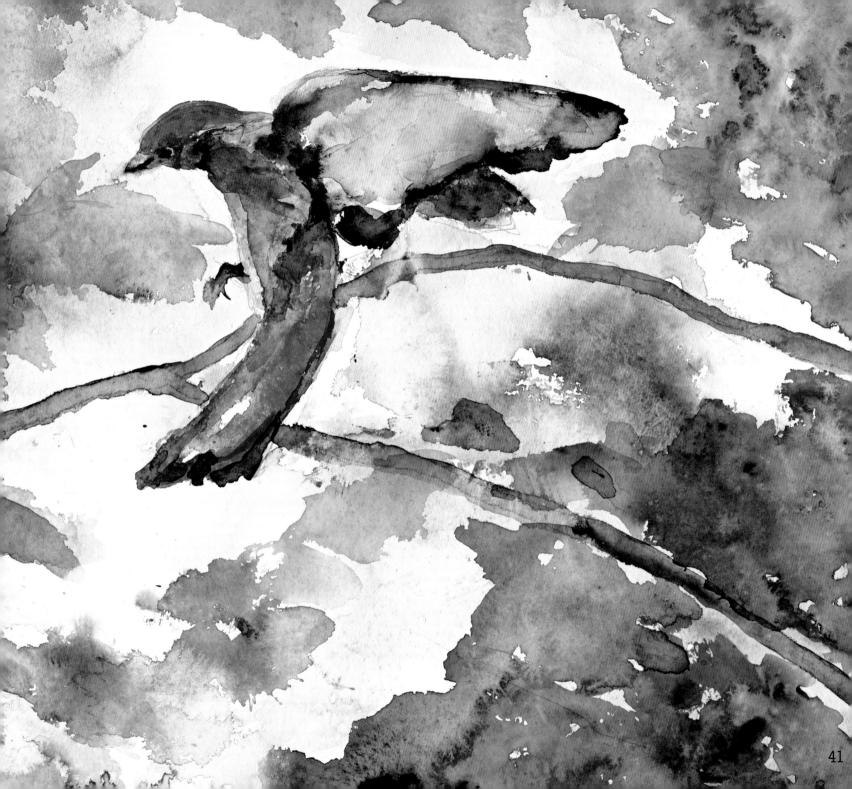

Rolling Stones, and his death a short while later. "He really got off on the trip of being a pop star. And it killed him. Suddenly, from being very serious about what he wanted to do, he was willing to take the cheap trip. And it's a very short trip."

I've read that most Nobel Prizes for Physics are won for work done by people in their late twenties, before they become immersed in the politics and institutions that open doors to them because they won the Prize.

John Graves wrote *Goodbye to a River*, a book that is a true work of art that also happens to be a book about a canoe trip. Graves poured his heart and soul into that book, and then threw the kitchen sink in too. Its unorthodox cadence, its rhythm, is a thing of beauty. With the royalties he bought some land and built a house. Alfred Knopf, his publisher, expressed concern that when a writer buys some land, his productivity goes way down. It was fourteen years before Graves wrote another book — a collection of essays — a good book but nothing remotely close to the brilliant *Goodbye*.

Digging deep is hard work. It's easily avoided.

March 20

From *Goodbye to a River*:

Elm stinks, wherefore literal farmers give it a grosser name, but it makes fine lasting coals. That morning I was up before dawn to blow away the ashes from the orange-velvet embers underneath, and to build more fire on them with twigs and leaves and brittle sticks of dead cottonwood. I huddled over it in the cold, still, graying darkness and watched coffee water seethe at the edges of a little charred pot licked by flame, and heard the horned owl stop the deceptively gentle five-noted comment he casts on the night. The geese at the island's head began to talk among themselves, then to call as they rose to go to pastures and peanut fields, and night-flushed bobwhites started whistling *where-you? where-you?* to one another somewhere

Painting on Previous Pages: Bluebird Rendezvous

above the steep dirt river bank. Drinking coffee with honey in it and canned milk, smoking a pipe that had the sweetness pipes only have in cold quiet air, I felt good if a little scratchy-eyed, having gone to sleep the night before struck with the romance of stars and firelight, with the flaps open and only the blanket over me, to wake at two thirty chilled through.

On top of the food box alligator-skin corrugations of frost had formed, and with the first touch of the sun the willows began to whisper as frozen leaves loosed their hold and fell side-slipping down through the others that were still green. Titmice called, and flickers and a red-bird, and for a moment, on a twig four feet from my face, a chittering kinglet jumped around alternately hiding and flashing the scarlet of its crown. . . . I sat and listened and watched while the world woke up, and drank three cups of the syrupy coffee, better I thought than any I'd ever tasted, and smoked two pipes.

You run a risk of thinking yourself an ascetic while you enjoy, with that intensity, the austere facts of fire and coffee and tobacco and the sound and feel of country places. You aren't, though. In a way you're more of a sensualist than a fat man washing down sauerbraten and dumplings with heavy beer while a German band plays and a plump blonde kneads his thigh. . . . You've shucked off the gross delights, and those you have left are few, sharp, and strong. But they're sensory. Even Thoreau, if I remember right a passage or so on his cornbread, was guilty, though mainly he was a real ascetic.

Real ones shouldn't care. They ought to be able to live on pâté and sweet peaches and roast suckling pig or alternatively on cheese and garlic in a windmill or the scraps that housewives have thrown in begging bowls. Groceries and shelter should matter only as fuel and frame for life, and life as energy for thought or beyond-communion or (Old Man Goodnight has to fit somewhere, and a fraught executive or two I've known, and maybe Davis Birdsong hurling his bulldozer against the tough cedar brush in a torn shirt and denim plants, coughing yellow flu sputum while the December rain pelts him, not caring) for action.

But I hadn't set up as an ascetic, anyhow. I sat for a long time savoring the privilege of being there, and didn't overlay the taste of the coffee with any other food. A big red-brown butterfly sat spread on the cottonwood log my axe was stuck in, warming itself in the sun. I watched until it flew stiffly away, then got up and followed, for no good reason except that the time seemed to have come to stir and I wanted a closer look at the island than I'd gotten the evening before.

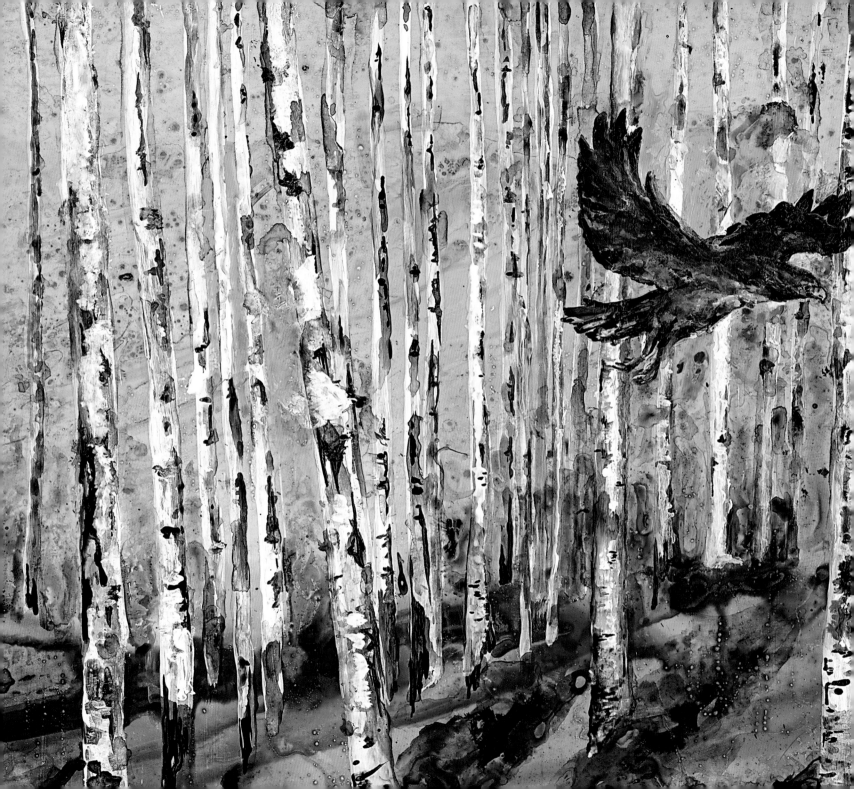

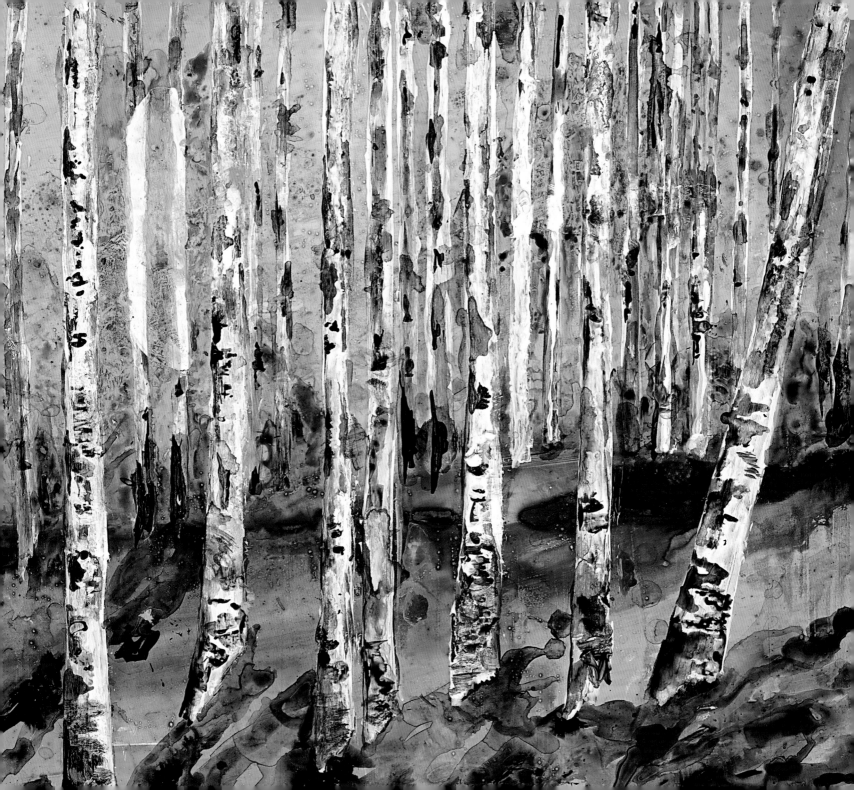

March 25

Keith Richards said, when asked about the widely-reported near-death experiences he's had from drug abuse, "I've lived my life my own way, and I'm here today because I've taken the trouble to find out who I am." Watching his interviews on YouTube, you get the impression that he's right. He's sitting there at 9 in the morning chain-smoking, obviously inebriated, and he's in harmony with himself, relaxed with himself, happy with himself. There's something life-sustaining about that.

I look back at the deep, dark days of Wall Street, prior to cancer, and realize that I wasn't in harmony with myself, wasn't happy with myself. I had fantasies about death — happy fantasies.

March 30

> To paint is not to copy the object slavishly, it is to grasp a harmony
> among many relationships.
> - Paul Cézanne

Painting the harmony — that's challenging. Maybe, in part, that's because living in the harmony is a challenge. It's a balance of disparate elements. You can't just take a canvas and paint it light blue. Or maybe you can. After all, you're an artist not a mouse. You can do whatever you want! That's the best thing about being an artist.

Harmony consists of peaceful meadows where birds sing at evening and lightning storms pass, of predators and prey, of starvation and times of plenty, of the emergence of new species and the extinction of others. To capture some aspect of that — the harmony of that, the soul of that, the beauty of that, the sorrow of that — is the challenge of the artist.

To paint, sculpt or write out of the underlying harmony without dogma, without pretense or artifice, is a challenge worthy of the creative life.

Painting on Previous Pages: Birch Forest

Stravinsky said he strove, in his music, to achieve a "harmony of varieties." "Variety," he said, "is valid only as a means of attaining similarity. . . . Similarity is hidden; it must be sought out . . ."

Through the creative process, the artist hopes to build a harmony with something. Maybe that something is deep inside or deep in the universe.

And sometimes great work is created out of disharmony. That's the paradox.

April 2

The woods have exploded into green these last two weeks. Nightfall is accompanied by a chorus of birds so loud that you sometimes have to raise your voice to be heard. Life, life explodes around us.

> When I judge art, I take my painting and put it next to a God-made
> object like a tree or flower. If it clashes, it is not art.
> - Paul Cézanne

April 6

> A creative person is one who enjoys, above all else, the company of his
> own mind.
> - Denise Shekerjian from the book *Uncommon Genius*

Beethoven composed his greatest work, including the Ninth Symphony, when he was stone deaf. His music came from deep inside.

April 10

> In 1863 Napoleon III created by decree the Salon des Refusés, at which paintings rejected for display at the Salon of the Académie des Beaux-Arts were to be displayed. The artists of the refused works included the young Impressionists, who were considered revolutionary. Cézanne was influenced by their style but his social relations with them were inept — he seemed rude, shy, angry, and given to depression. His works of this period are characterized by dark colors and the heavy use of black. They differ sharply from his earlier watercolors and sketches at the École Spéciale de dessin at Aix-en-Provence in 1859, and their violence of expression is in contrast to his subsequent works.
> - from the Wikipedia page on Paul Cézanne

I admire Napoleon III for creating a second salon for those rejected by the dominant art experts of the time. Thinking that makes room for the new, the threatening, the rejected is important to human advancement.

Picasso painted *Demoiselles d'Avignon* in 1907, when his work was just starting to sell. It is now widely regarded as one of the great paintings of the twentieth century, but at the time was generally thought of as bizarre. Some even regarded it as an indication that Picasso might be going mad. Daniel-Henry Kahnweiler, a prominent art dealer, who later became Picasso's main dealer, regarded it as a failure.

André Salmon, a close friend, noted that some of Picasso's fellow painters began avoiding him. Picasso turned to an imaginary world of African soothsayers for support, and began to paint grimacing nudes.

Matisse knew from experience that the public's negative reactions to new art were often directly related to the potency of the truth the

art contained. No one knew better than Matisse that the most serious painting of a given moment would necessarily be at odds with the conscious ideas of the public. And no one who saw *Les Demoiselles* was indifferent to it. After initial reactions of horror at its ugliness, a number of artists were inspired to try to imitate it, though somewhat tamely. As Picasso told Gertrude Stein, the person who creates a thing "is forced to make it ugly" by the very intensity of the struggle to create and because he doesn't yet know what he is going to create, whereas "those who follow can make of this thing a beautiful thing because they know what they are doing, the thing having already been invented."

 - from *Matisse and Picasso: The Story of Their Rivalry and Friendship* by Jack Flam

April 12

A work of art reflects the mental state of the artist.

Looking back over the roughly one thousand paintings I've done in the last fifteen years, I notice that I paint dark paintings when I feel overwhelmed, disconnected from the creative currents that underlie my life.

 The brush stroke at the moment of contact carries inevitably the exact state of being of the artist at that exact moment into the work. A work of art is the trace of a magnificent struggle. . . .The mistakes left in a drawing are the record of the artist's struggle.
 - Robert Henri, *The Art Spirit*

A work of art is the trace of the work an artist has done with

49

himself, with herself.

Mistakes are often bridges into unexpected, creative possibilities.

April 13

Soetsu Yanagi, Japanese potter, offers a Zen perspective on art and imperfection in his book, *The Unknown Craftsman*. Beauty and freedom go together, and freedom involves imperfection.

Why should one reject the perfect in favor of the imperfect? The precise and perfect carries no overtones, admits of no freedom; the perfect is static and regulated, cold and hard. We in our own human imperfections are repelled by the perfect, since everything is apparent from the start and there is no suggestion of the infinite. Beauty must have room, must be associated with freedom. Freedom, indeed, is beauty. The love of the irregular is a sign of the basic quest for freedom.

The Buddhist aesthetician Shin'ichi Hisamatsu put forward a new idea. He says that the imperfect does not, in itself, constitute beauty. The imperfect is merely a negative concept. True beauty in the Tea ceremony must be more positive. It must go further, to the point of positively rejecting the perfect. . . . The shape of Raku Tea-bowls is deliberately deformed – by, for example, not using a wheel – and the surface is left rough. By such means the masters sought to give life back to beauty in the Tea ceremony.

All works of art, it may be said, are more beautiful when they suggest something beyond themselves than when they end up being merely what they are.

Unlike other collectors, most Tea masters prefer the incomplete; they look for slight scars or irregularities of form. If carried to excess, this desire will, of course, become unhealthy, but that there is a close relation between beauty and deformation cannot be denied. Beauty dislikes being captive to perfection. That which is profound never lends itself to logical explanation: it involves endless mystery.

Painting: Hawk Owl Landing II

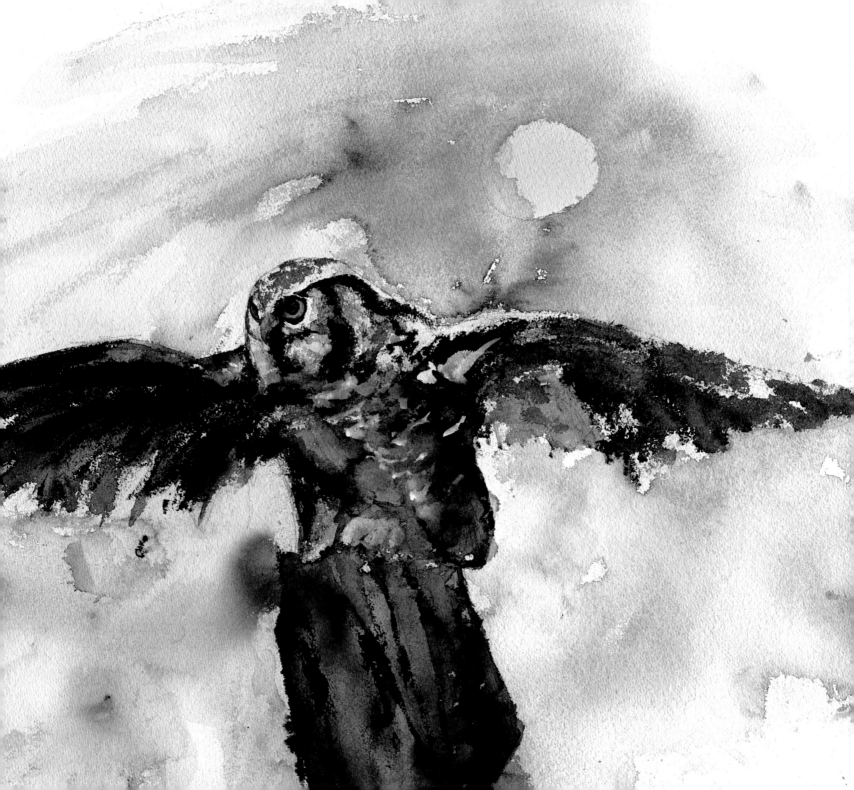

April 15

I've learned to hold on to my failed paintings for a year or two. I've taken some of my favorite paintings, and some of my best-selling images, out of the reject pile. At the time I painted them, I set them aside because they weren't what I had in mind. Looking at them a month or a year later however, I sometimes discover something special. You need time to elapse before you can properly judge your work.

April 20

Of course, some failures are failures, plain and simple. Art is an experimental activity. Even the great masters of art fail more often than they succeed. Out of fifty thousand paintings or sculptures, Picasso is known for a thousand, at most.

Accept that failure will happen more often than success, and keep trying. You don't need a lot of successful images or books to make it as an artist or writer. You need persistence and a thick skin.

April 21

Like many artists, including artists now widely acknowledged as "great," Henry Miller was prone to periods of self-doubt. He wrote in *Tropic of Cancer*:

> I'm lying on the iron bed thinking what a zero I have become, what a cipher, what a nullity, when bango! out pops the word: NONENTITY.

Twenty-five years later, when he was living in Big Sur and had written many of his greatest books, he wrote his friend Lawrence Durrell:

> I'm going through some sort of crisis. Never felt more desolate. Yet

Painting on Previous Pages: Lake Bound

underneath very hopeful. Two nights ago I got up in the middle of the night with the firm intent of destroying everything — but it was too big a job . . . I seem to feel that all I have done is to create a booby-hatch. Now I can throw the letters away without replying. It's easy. The next step is to throw myself away. That's harder. One thing seems certain — that I've built on sand. Nothing I've done has any value or meaning for me any longer. I'm not an utter failure, but close to it. Time to take a new tack. Years of struggle, labor, patience, persistence have produced nothing solid. I'm just where I was in the beginning — which is nowhere.

And again, in his 80's, twenty years after he had achieved international recognition, he said to his friend Georges Belmont:

I often ask myself if I haven't been a failure. My opinion is that I've been a failure for most of my life. And still am today.

April 24

Writing is a form of therapy; sometimes I wonder how all those who do not write, compose or paint can manage to escape the madness, the melancholia, the panic fear which is inherent in the human situation.
- Graham Greene

April 28

The most demanding part of living a lifetime as an artist is the strict discipline of forcing oneself to work along the nerve of one's own most intimate sensitivity.
- Anne Truitt, sculptor

Art explores what the artist finds most profound about life but can't quite come to terms with. The questions that have no answer: your vulnerabilities, your preverbal world, your emptiness, your fullness, your personal myth. Your loves.

Each of us has a myth, a symbolic presence, at the center of our lives. Yours is unique to you, mine is unique to me. It is both our deepest truth and a fantasy; its basis is in both reality and the dream-world of the subconscious. You may know exactly what it is or you may be totally unaware of it. Often it can't put it into words. You sense it as vague shapes and powerful emotions. It accompanies you in your dreams at night. It takes form in childhood. For good or ill, it accompanies us through life. Sometimes it guides us to self-destruction; sometimes our rebellion against it or our decision to ignore it leads to self-destruction. Our relationship with it determines our relationships with other people, with nature, freedom, captivity (helplessness), security. If you're a soldier fighting in Afghanistan or a volunteer working in a soup kitchen in Boise, Idaho, you're living out your myth. For an artist, it is important to think through the role that one's myth will play in your work. All great art comes from a kind of primeval encounter, maybe even a struggle, deep down inside, somewhere between light and dark – the conflict between mythological reality and concrete pavement, the dark shadows of night and the blinding sun of morning. Out of darkness, is sometimes created beauty. Sometimes that beauty is dark and shadowless.

The inner voice of the psyche needs nurturing so that the lost soul can be rediscovered — the soul of creativity.

April 29

Once having traversed the threshold, the hero moves in a dream landscape of curiously fluid, ambiguous forms, where he must survive a succession of trials.
- Joseph Campbell, *The Hero With a Thousand Faces*

Artists cross a similar threshold, one also of "curiously fluid, ambiguous forms" where "a succession of trials" must be endured. The threshold the artist crosses is into the world of the imagination, the

dreamworld, the world of core, underlying truths that can be sensed but not fully understood.

April 30

I recently watched Amy Tan give a presentation on TED.com. She's the best-selling author of *The Joy Luck Club*, among others, and she said that before she writes, she first has to overcome the feeling that she is an impostor. Almost all artists deal with this at one time or other. Some deal with it every day, but as long as one can get past it, it's irrelevant.

A huge world, a huge universe with huge possibilities, surrounds us. Creative energies, the energies of green, growing things, energies of wind and water, the energies of the universe, swirl around. I try to tune into them. Sometimes I succeed. It isn't easy. There's a discipline to it. Sometimes I lack discipline.

The goal is to hook into energies, consciousness that is larger than our own narrow view. The goal is to be open to the possibilities, let them into our psyche, our soul. Live them. The constant tendency is to self-protect, to take the small view, the petty view. Fear, feelings of inadequacy, the small little scared person inside wants to take over.

Caruso, the great operatic tenor, suffered from severe stage fright. Before performances, he experienced spasms and paralysis in his throat. He'd perspire heavily. He'd imagine the audience laughing at him as he tried to sing and couldn't. He dealt with it by envisioning a Little Me and a Big Me. The Little Me was fear, the Big Me the song inside that wanted to come out. He'd tell himself, "The Little Me wants to strangle the Big Me within." He said to the Little Me, "Get out of here. The Big Me wants to sing through me. Get out, get out, the Big Me is going to sing!" Then he'd walk out and astound the audience.

I sit down to write and paint, and I think, "Who am I trying to kid? I'm not a writer. I'm not a painter. What makes me think I've got anything to offer of value?" I get out of that rut by telling myself that "Well, that may be true, but that doesn't mean anyone else has anything more to say. After all, you hitchhiked back and forth across the country in your mid-teens. You've fought forest fires with Dogrib Indians and worked on Wall Street. After all, you've failed, failed, failed and failed again. And then you kept trying. You've lived a full life. Write and paint out of that.

I say to myself, "Tap into the times you had courage, tap into your failures, your successes. Tap into your most profound experiences. Develop possibilities, make them real. Confront your fears. Expand your view to include the infinite. Meditate. If you go down deep enough, you find the universe, and the universe will guide you."

And always the small, narrow-minded entity wants to take over, and lead me down the apparently easy road. The chicken voice is always there. But it is irrelevant. Ignore it.

May 4

An artist starts out where things are not under control. That probably includes both creative work and financial security. An artist must be able to deal with fear. (Was it Hemingway who said that fear is the inability to suspend your imagination?) There is the fear of hunger and homelessness, but there is also the fear of creating work that no one cares about, that is rejected or even ridiculed.

An artist needs to work just beyond his or her capability, just beyond safety. You don't want to go too far and be foolish. You need to work with a degree of humility, but you can get energy from fear. Fear can lead to work that is transcendent, that is spiritual, that is alive. Transcendent work is done in uncharted waters.

May 7

Most of them said "you're alone?" or "Just a single then?" I said I was
in publishing. I said I had a week off. I said I liked to walk. I did not
say that I had no choice but to travel alone because I could only think
clearly when I was alone, and then my imagination began to work, as
my mind wandered . . . I talk to myself — talking to myself has always
been a part of my writing . . .
 - from *Kingdom by the Sea* by Paul Theroux

May 8

Downtime is a crucial part of the creative process. Time to do nothing. Time to be alone; time to be
with gentle company. An absence of stimulation, except of the loving, sensual kind. Diving down
deep, finding your creative core, your spark, and then manifesting it in a completed work of art, is
hard work. The recovery time between creative work sessions is crucial, both for rest and for the
interaction of previously unrelated thoughts and feelings. Art creates the new out of the old.

. . . as a writer I have to work with my imagination and my mind, and therefore I must lead
a life that does not take my imagination away from my work — which means that I must go
away from people at times. I find that the most important part of working is not the
period when I am actually writing, but the periods when I stop writing between one
day and the next morning. That period is terribly important, and though I cannot write
in it, it is one in which my imagination should not be caught up in other things since it
is an instrument of my writing. That is the sort of incubation period, a time of vulner-
able growth. Something goes on, and I like then to go on long walks in the country just
by myself. I would love to write twenty-four hours a day, but words are so exacting,
such hard work, that I cannot do more than three or, if I am lucky, four hours at a
time, however much I long to push on. So, in between, I am anxious to get on to the

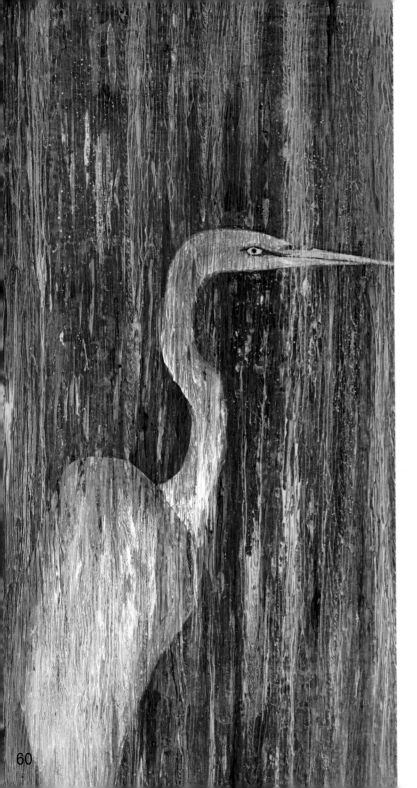

next morning; I can hardly wait to get back to it.

 - Laurens van der Post, *Walk With A White Bushman*

I am almost incapable of logical thought, but I have developed techniques for keeping open the telephone line to my unconscious, in case that disorderly repository has any-thing to tell me. I hear a great deal of music. I am on friendly terms with John Barley-corn. I take long hot baths. I garden. I go into retreat among the Amish. I watch birds. I go for long walks in the country. And I take frequent vacations so that my brain can lie fallow — no golf, no cocktail parties, no tennis, no bridge, no concentration, only a bicycle.

 - David Ogilvy, *Confessions of an Adver-tising Man*

Sometimes those in our lives, those we love and who love us, don't understand this. They take it personally. An artist needs the company of her own mind; revels in that company.

Perhaps the most difficult lesson for me over the fifteen years of HERON DANCE ha been related to my inability to handle stimulation, to worry about the countless details that an effort like this involves. That includes managing people. I've continually

Painting: Leaves of Grass

tried and continually failed. When I get into that scenario, vague images of death spirals, of a convulsing animal shuddering out its life come to mind.

May 9

Years ago, I copied the following out of the introduction to a book about a prominent West coast artist, Morris Graves. I think the book was *Morris Graves, Vision of the Inner Eye* by Ray Kass.

> He comes from the Pacific Northwest; an exceedingly tall thin figure, with large transfixed, rather alarmed eyes. Graves wears a close-trimmed full beard, and there is something of D. H. Lawrence, grown double height in the Northwest climate. He is shy and self-aware to a degree, aloof, yet (you suspect) ruthless in his self-determination. He seems devoid of the secret embarrassment of being born an artist, and has no desire whatever to be like anyone else. "Making your own life," is a recurrent phrase.
>
> His privacy is defended by many hurdles and warnings. Purposeful ruts are left deep in the road by which you approach his house, and signs say "no trespassing, no peddlers, no unauthorized persons," in short: "No." The final hurdle is Graves's ritualistic politeness, a self-restraint which is limited by his sense of farce. In short, he is very birdlike: receding, private, mobile, and migratory. He is birdlike with his different, yet natural, control over the space we share; but mostly, on reflection, he has the willful steely quality of a bird — its capacity to survive. You are meeting him in the region north of Seattle from which he comes.
>
> His home is deep in hundred-foot trees, the building his own handiwork, an extravaganza in protective space by a man who has always opposed himself to "middle-class gregariousness." Follow him

at once into his studio, which is workmanlike, and realize that it is an ordeal for him to throw it open. The place is bare, the walls white. Outside the window there is a dwarfed pine, symbol of the "concentrated treatment of nature in Japan," and immediately beyond is a high white wall. A stove, high tables at which he can work standing, a few odd accidental objects, a Giotto print on the wall, something of Siena, and two ambivalent photographs from Chartres, a demon and a Christ.

There are sheaves of drawings: black chalk, charcoal, pencil on tan paper, kept with the casualness with which they were created. There are fragments from the various periods; the Inner Eye birds, the Journeys, the Pines. A roll of the early oils is of interest: a Red Calf Series — symbolism even before he had recognized his trade. One feels something being taken captive in the drawings and paintings, and Graves — uneasily hovering over his disrupted privacy — seems to be struggling to tame himself.

On the wall there is a sort of credo. Quotations from Chinese painters of the Sung period, which conclude with the words of Ni Tsan:

Powerful and full of feeling Subtle and expressive of thought
Light as floating clouds Vigorous as a startled dragon
His ideas are like clouds floating in space, or a stream hurrying
along — perfectly natural
Zen means for a man to behold his own fundamental nature
What I call painting is no more than a
careless fantasy of the
brush, not aiming at resemblance
but only at the diversion of the
painter.

May 10

> No great work has ever been produced except after a long interval of
> still and musing meditation.
> - Walter Begehot

I remember listening to an interview of David Lynch, filmmaker (*Eraserhead, The Elephant Man*, among others) on the radio maybe twenty years ago. One thing he said has particularly stuck with me. When deciding on a new film project, he waits for an idea that grips his imagination on a visceral level. Then he waits a few months. If the idea still has a deep, emotional grip on him, he goes ahead.

> You cannot force creativity. I do not see this process as being under
> my conscious control. It is a process of percolation, with the form
> eventually finding its way to the surface. . . .
> I do not think that we can fully understand how one makes
> a specific mark upon a page — at some point one has to trust one's
> eye, one's intuition. I do not think that that implies a lack of rational
> thought. I just think that one cannot understand why one makes a
> specific move, that the creative act is a combination of conscious and
> subconscious thoughts that cannot or should not be deciphered.
> My creative process balances analytic study, based very much
> on research, with, in the end, a purely intuited gesture. It is almost as
> if after months of thinking I shut that part of my brain down and allow
> the nonverbal side to react. It is this balance between the analytical
> and the intuitive, or between the left side and the right side of the
> brain, that is so much a part of these works.
> - Maya Lin (designer of the Vietnam Veterans War Me-
> morial) in her book *Boundaries*

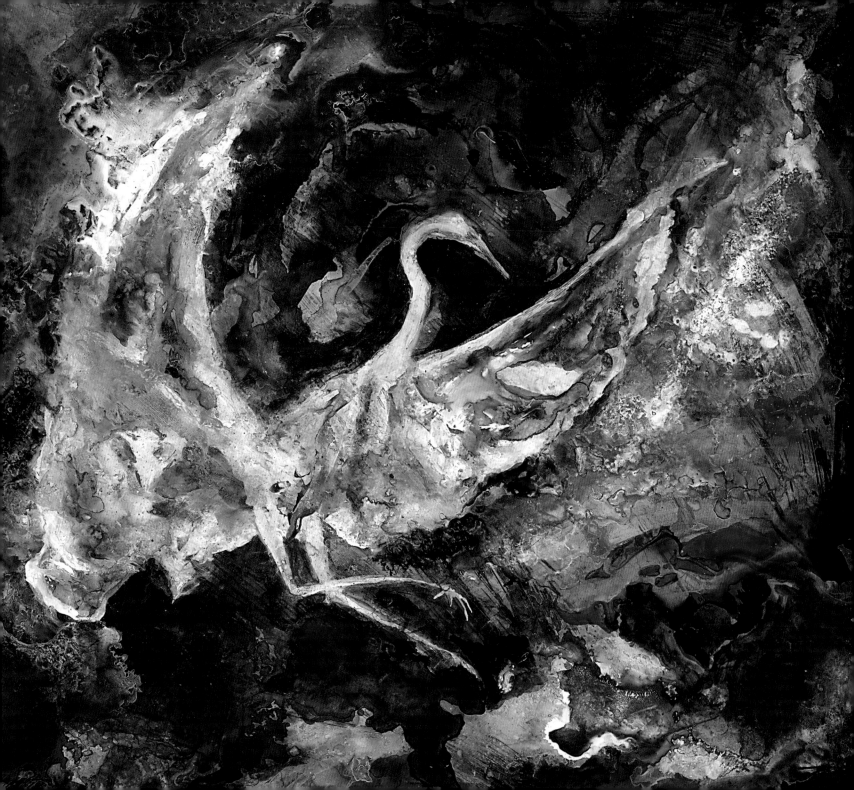

May 15

When I lived in Toronto, I used to occasionally see Robertson Davies wandering around downtown. He was easy to spot — he had a particularly beautiful, long white beard. He was a novelist, playwright, critic, journalist and university professor. His work, in particular his novel *A Mixture of Frailties* and the libretto he wrote for an opera, *The Golden Ass,* were influenced by *Metamorphoses,* the book mentioned earlier that was written in 8 A.D. .

I once heard him interviewed and the thing that stuck with me was his strongly held view that his daily afternoon nap was crucial to his creative process. Naps allowed him to develop his own pattern of work and rest, on his own terms. And naps allowed his mind time to take seemingly unrelated ideas and work them into a creative strand.

When asked whether or not he used a computer when he wrote, he said:

> I don't want a word-processor. I process my own words. Helpful people assure me that a word-processor would save me a great deal of time. But I don't want to save time. I want to write the best book I can, and I have whatever time it takes to make that attempt.

May 20

> Writing is about hypnotizing yourself into believing in yourself, getting some work done, then unhypnotizing yourself and going over the material coldly.
> - Anne Lamott from *Bird by Bird*

If you try to write from a critical mindset, you won't get anything done. You need to let go. Let 'er rip. During creative time, suspend judgment.

Painting: Egret Was Here

The secret of the creative life is often to feel at ease with your own embarrassment. We are paid to take risks, to look silly. Some people like racing car drivers are paid to take risks in a more concrete way. We are paid to take risks in an emotional way.

 The film critic is like a medical examiner. He gets the cadaver on the table, he opens it up, and tries to figure out why it died. The filmmaker is like the pregnant mother who is simply trying to nurture this thing. You have to keep the medical examiner out of the delivery room because he will get in there and he will kill that baby.

 - Paul Shraeder, interviewed by Terry Gross, *Fresh Air*

The role of your intuition is to create. The role of your ego is to protect you. The role of your rational mind is to critique. Don't confuse the three.

An artist needs to find his or her edge and jump off. It is a different edge for each one of us. To jump off, we need to believe in our own song, the one that no one else can sing. Some days the courage and discipline that takes are hard to come by, but on the other side of it is freedom. Freedom, harmony.

The young man sitting there in the mingy yellow light became completely unhinged; he lived in the crevices of great thoughts, crouched like a hermit in the barren folds of a lofty mountain range. From truth he passed to imagination and from imagination to invention. At this last portal, through which there is no return, fear beset him. To venture further was to wander alone, to rely wholly upon oneself.

 The purpose of discipline is to promote freedom. But freedom leads to infinity and infinity is terrifying. Then arose the comforting thought of stopping at the brink, of setting down in words the mysteries of impulsion, compulsion, propulsion, of bathing in the senses of human odors.

 - Henry Miller, *Sexus*

When an artist is in harmony with the reality out beyond that edge, the reality of imagination, life is pretty good. When an artist is in harmony with his work, with her work, life is good.

May 22

Einstein worked through body sensations — most of his concepts came to him in a preverbal state. Kekule's idea of the benzene ring appeared to him in a dream-like reverie. Mozart directly "heard" his music. And the world's best mathematicians solve complex problems not through analysis, but through intuition.

Extremely gifted people have command of many different states — and are able to switch instantly from one mode to another. Inventors and artists are not alone in doing this: top athletes note that their peak performances coincide with shifts in consciousness. Using guided imagery, Eastern European athletes have set new standards in recent Olympic games.

- "Noetics at Work," publication unknown but perhaps *The Tarrytown Letter,* roughly 30 years ago

An artist needs to set aside time to allow fantasies the opportunity to pursue their path without conscious intervention. This allows new ideas, new opportunities, new paths in life a chance to open up of which you may have been only vaguely aware.

May 24

Art is the spirit in matter, the natural instinct toward humanization, that is, toward the spiritualization of life . . . Man's conception of art as the natural instinct toward humanization, or spiritualization, provides a bridge uniting the fine and

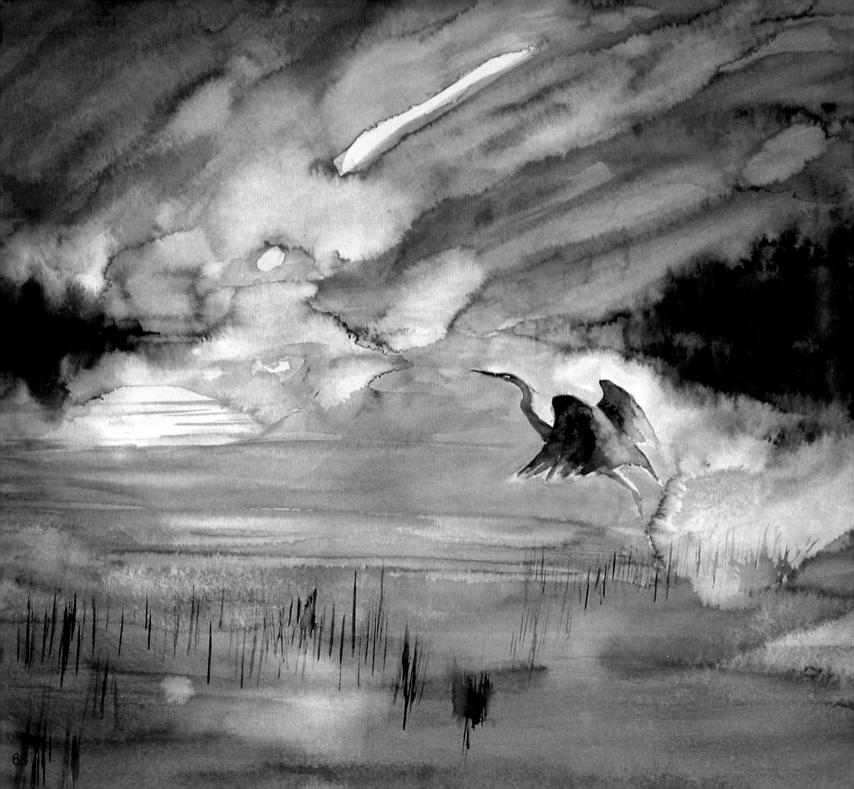

the practical arts, the spiritual life with the art of creative living. . . .
- Thomas Mann

This conception unites the work of Gandhi with the Japanese tea ceremony, the mission work of Albert Schweitzer with Mozart's Magic Flute, Navaho sand painting with the great cathedrals of Europe, the work of Mother Teresa with that of Goethe, the poetry of the Troubadours with the scriptures of India, the work of Albert Einstein with that of the anonymous but devoted local elementary school teacher. All of these are art because they spring from what Mann calls the natural instinct to humanization.
- Laurence G. Boldt, *Zen and the Art of Making a Living*

June 15

Art gets its power in part from the artist's search for truth.

There is nothing ugly in art except that which is without character . . . only the false, the artificial, is ugly in art.
- Auguste Rodin

The hero of my talk,
whom I love with all the power of my soul,
whom I have tried to portray in all his beauty,
who has been, is, and will be beautiful, is Truth.
- Leo Tolstoy

I believe that it is a writer's duty to speak the truth, especially unpopular truth. Especially truth that offends the powerful. It is a writer's obligation, I believe, to be a critic of the society he lives in. If the inde-

pendent freelance writer will not speak the truth to us and for us, then who will? Do we get the truth from politicians? Do we get the truth from Chambers of Commerce? Do we get the truth from the bureaucrats of government? From the Cattlemen's Association? From *Time* or *Newsweek* or CBS or ABC or NBC? Do we get the truth from the TV evangelists of commercial religion? Do we even get much truth from science and scientists?

Well, we get some. But not enough. It seems to me that the majority of scientists are specialized technicians. Most of them long ago sold their souls to commerce, to industry, to government, or war. Therefore, I repeat, it is the writer's duty to speak truth – you notice I carefully don't attempt to describe or define truth, however offensive that truth may sometimes be.

I'm going to quote Tolstoy here. In one of his earlier books, Tolstoy said, "The hero of my work, in all his unadorned glory and beauty, is truth."

Truth is always the enemy of power. And power is always the enemy, at least the potential enemy – of truth. Writers who shirk from telling the truth, who simply go with the flow (who pander, for example, to those East Coast literati, my dead enemies). . . .writers who do that are merely hacks. Hemingway once said it, and said it good, in respect to power, governmental power: "A writer is like a gypsy. He owes no allegiance to any government. If he's a good writer, he will never like any government he lives under. His hands should be against it, and its hand will always be against him."

This from a letter that probably got him into all kinds of trouble. He probably died in some labor camp.

- Edward Abbey, from the speech Something about *Mac, Cows, Poker, Ranchers, Cowboys, Sex and Power*

The Cave, The Buffalo Bones

Out on the edge of the prairie, there is a cave
Fragments of buffalo bones scattered about.
Wild flowers in the spring, wild winds
Storms move across the horizon.
The sun rises through prairie grass.

At sunrise, the world comes alive
A bird song from far off,
Filters through cool air.
Shadows shift, take form, and disappear.
Abstract images sweep the
Prairie towards you
Sit beside you
Then disappear.

The wind blows the grass flat.
In waves of blue then brown, then green.
Something is out there.
Something alive. Something scary.
Something beautiful.

I sit and watch with eyes closed
And wonder about this place
What it means to me
And how to paint that. That.

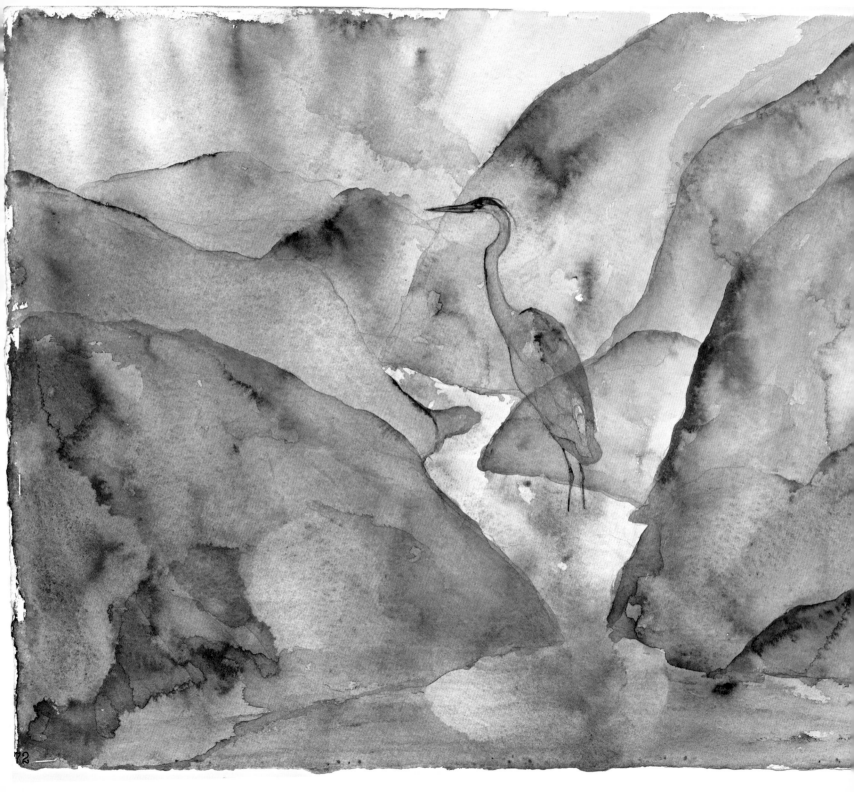

. . . the act of writing asks always more of the self.

To write truthfully, the writer learns to summon courage, and learns to summon, along with that courage, both the coldness needed to love truth more than oneself and the heat needed to love the real with such passion the writer will follow it anywhere.
- Jane Hirshfield, *Making Soul*

June 16

Athletes take care of their bodies. Writers must similarly take care of the sensibility that houses the possibility of poems. There is nourishment in books, other art, history, philosophies — in holiness and in mirth. It is in honest hands-on labor also; I don't mean to indicate a preference for the scholarly life. And it is in the green world — among people, and animals, and trees for that matter, if one genuinely cares about trees. A mind that is lively and inquiring, compassionate, curious, angry, full of music, full of feeling, is a mind full of possible poetry. Poetry is a life-cherishing force. And it requires a vision — a faith, to use an old-fashioned term. Yes, indeed. For poems are not words, after all, but fires for the cold, ropes let down to the lost, something as necessary as bread in the pockets of the hungry. Yes, indeed.
- *Mary Oliver*, poet

A good book should be an axe for the frozen sea within

Painting: Up on Trickle Creek

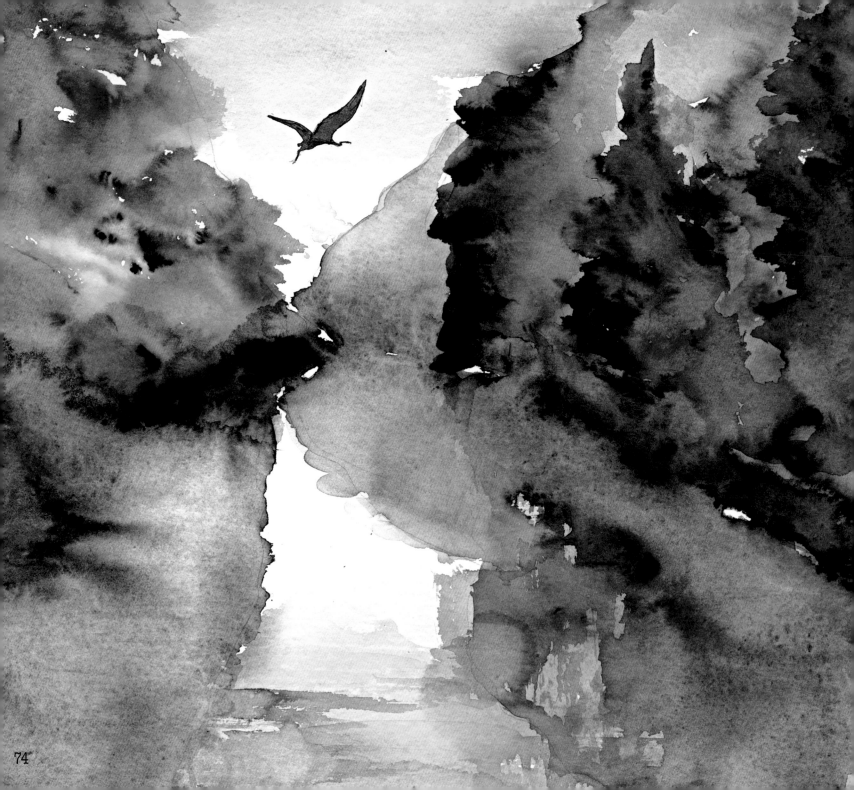

us.

> - Franz Kafka

It is difficult to get the news from poems
Yet men die miserably
every day for lack
of what is found there.
> - William Carlos Williams

The poets are wrong of course. . . . But then poets are almost
always wrong about facts. That's because they are not really
interested in facts: only in truth: which is why the truth they
speak is so true that even those who hate poets by simple and
natural instinct are exalted and terrified by it.
> - William Faulkner, *The Town*

June 20

My fight for sculpture uses up all of my time and strength, and
even then I lose.
> - Auguste Rodin

I sculpt salmon over and over. Because that needs to happen,
for me and the place here. To create that tilth. You create that
salmon over and over. You are bored beyond tears. You finally
get it. You told the story three hundred times, and you finally
came to realize what the story was about. I don't know what the
story is half the time, but I keep trying. I made probably twenty

Painting: The Boquet, Early Morning

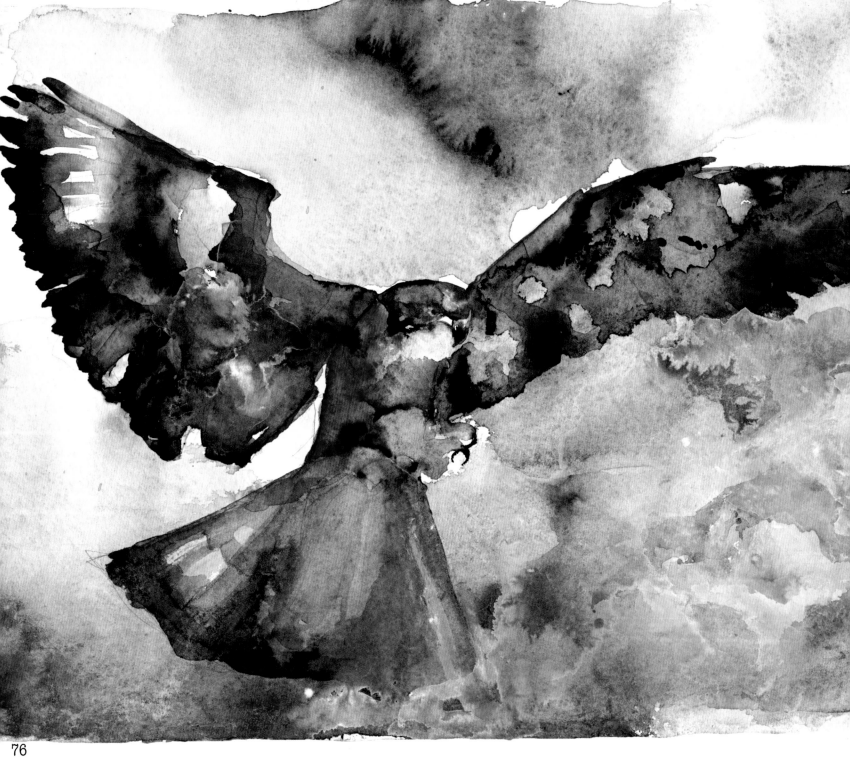

salmon before I started to get anywhere. And now, I think I can make a hundred and fifty more before I really get it right, if ever. Maybe. No guarantees. If I pay attention and work on it, and listen, and watch, maybe someday I'll make a salmon that honors the critter.
- Tom Jay, "Civilization is Entropy in Drag," (Issue 24, HERON DANCE)

The total number of artworks Picasso produced has been estimated at 50,000, comprising 1,885 paintings; 1,228 sculptures; 2,880 ceramics, roughly 12,000 drawings, many thousands of prints, and numerous tapestries and rugs.
- Wikipedia

I think I read that in the last ten years of his life, Picasso produced 20,000 works of art.

The real essence of work is concentrated energy.
- Walter Begehot

Barry Moser illustrator of books — including over 200 children's books I think — and wood engraver, talked about focus, persistence and hard work in his book, *In the Face of Presumption, Essays, Speeches & Incidental Writings:*

As I tell my students, persistence is really what this business is all about. It has little to do with talent. Talent's about as valuable as tits on a boar. What is valuable is persistence, determination, drive, desire, patience, indefatigable energy, the willingness to fail, and luck. Never underestimate luck, I tell them. I've been teach-

Painting: Kestrel Landing

ing for thirty-six years now, and I've never met a student who didn't have talent. By the same token I can count on one hand the ones who manifest all the qualities I've just listed — and I'd have some fingers left over. . . .

It is a fact that no one ever made a wood engraving or wrote a sestina by merely being creative. That's like a tail wagging a dog, for God's sake. Rather than teaching kids to be "creative" they should be taught what art really is. They should be taught the history of its practitioners, and a good deal about the role craftsmanship plays in the process. They should be taught form, not finger paints. They should be taught that art, contrary to the conventional wisdom, is not self-indulgent. They should be taught that art does not come to those who wait. They should be taught that art comes from those who do — that the very genius of art lies in action. In doing. They should be taught that art comes from study and from hard work and from solid craftsmanship, they should know that beyond determination and persistence, art comes about only through study, work, and knowledge of their craft.

I have no record of how many students I taught over the years, but it has to be in the tens of hundreds. Based on that experience I can say honestly that I never met a student who was not "creative," nor did I ever meet one who was not "talented." A few of those students are now professional graphic designers, painters, architects, potters, and furniture makers. But why them and not the others, if, as I say, all of them were creative and talented?

The answer is simple: some of my students persisted and some did not. Those who did not persist were the ones lacking sufficient interest, drive, and discipline. Those who did persist persisted because they had energy, they had courage (or "sand" as my granddaddy would have put it), and they developed a need to work.

Painting: Night Bear

Moser's three rules for the so-called creative life, are, therefore,

Persistence
Indefatigable energy.
The habit of work.

George Duthuit described the state in which his father-in-law approached the act of painting, a tension so extreme that those closest to him risked being sucked in with him to the verge of breakdown or vertigo: "The obvious forebodings experienced by the painter — who is at the same time so prudent and so orderly that people call him 'the Doctor' — made him tremble. During the few years when he was able to endure this vision, Matisse spent whole nights without sleep, nights of desperation and panic." From now on, Matisse would never again be free from the insomnia that had first attacked him on Belle Ile. Amelie helped him through the interminable nights by reading to him, sometimes until dawn.
 - Hilary Spurling, *The Unknown Matisse*

The failures have always kept me working. It's not good enough. It's very good, but it's not good enough.
 - Georgia O'Keeffe

Twyla Tharp, in her book *The Creative Habit,* talked about the work habits of Mozart and Beethoven:

Nobody worked harder than Mozart. By the time he was twenty-eight years old, his hands were deformed because of all the hours he had spent practicing, performing, and gripping a quill pen to compose. That's the missing element in the popular portrait of Mozart. Certainly,

Painting: Autumn Travels

he had a gift that set him apart from others. He was the most complete musician imaginable, one who wrote for all instruments in all combinations, and no one has written greater music for the human voice. Still, few people, even those hugely gifted, are capable of the application and focus that Mozart displayed throughout his short life. As Mozart himself wrote to a friend, "People err who think my art comes easily to me. I assure you, dear friend, nobody has devoted so much time and thought to composition as I. There is not a famous master whose music I have not industriously studied through many times. …."

Beethoven, despite his unruly reputation and wild romantic image, was well organized. He saved everything in a series of notebooks that were organized according to the level of development of the idea. He had notebooks for rough ideas, notebooks for improvements on those ideas, and notebooks for finished ideas, almost as if he was pre-aware of an idea's early, middle, and late stages.

As artists, we try, we fail, but we keep trying. We offer our gift to the world, the world rejects it, and we keep offering. It helps to be compelled. It helps to have a vision, an emotion, a perspective so exciting, at least to its creator, that he or she is compelled to try to make it live. Like anything really important, putting creativity at the center of one's life involves sacrifice.

June 21

Abraham Maslow said that "A first-rate soup is more creative than a second-rate painting." For some, the highlight of life is preparing a meal for others that is full of love, that communicates love. That too is art. That may be an art form more conducive to a life that is balanced, that is more harmonious, than making one's living from writing, music or painting. But I'm not sure we choose these things. They choose us.

June 22

There is an enlightened life, there is a life of adventure and there is a creative life. Nurturing inner beauty leads to an enlightened life, a life that has elements of quiet, of balance and harmony. Such a person is calm, even in the face of chaos. An enlightened person lives with gratitude and quiet humility. An enlightened person may lack ambition; the enlightened person has found what they were looking for.

An adventurer seeks truth; an enlightened being has found truth. Adventure involves uncertainty, trials and tribulations. An adventurer may not be balanced or may become unbalanced as a result of ordeals encountered on the journey. Perhaps the adventurer hopes to find an interior balance during the process of confronting the unexpected.

I wonder if it is possible to live all three: an enlightened, adventurous, creative life. Probably not, but nevertheless I try. I try to live and create out of the peace and quiet I find in the natural world. I draw on my relationship with my inner world. I seek truth. I try to realize my potential. I try to create work of beauty. In the trying, the striving, is great satisfaction, despite the setbacks and failures. I celebrate my efforts, my willingness to keep trying. I celebrate the efforts of all who don't give up trying to develop their potential as artists, as human beings.

June 30

Part of what fascinates me about the lives of artists — and about physicists, mathematicians, too, for that matter — is that their work emerges out of their inner world, their preverbal world. They have penetrated themselves.

July 4

Lester Bowie was a 57-year-old jazz trumpeter when I interviewed him. He had recorded

or performed on 87 albums.

> I remember one time I was in Paris. I had a really painful, terrible case of hemorrhoids. But I played my heart out. Couldn't figure it out. I could hardly walk. Everybody was like, "Damn what's happening? We thought you was sick." So you never know. I just relax and go with the flow. If it happens, it happens. If it doesn't happen, I just try to do the best I can, and use the years of experience knowing how to play the song. When it's happening, it's just like bam! But if you are a pro, you play regardless of whether the spirit is with you. You can't quit and come back tomorrow.
>
> - Lester Bowie, HERON DANCE interview. *Jazz is the flower that still managed to grow*

July 15

How would you describe your deepest being? What part of you is connected to God? What part of you is incapable of falsehood? What part of you is growing, evolving? Create out of that place.

July 20

Focus for three hours a day on painting, and three hours on writing. When I do that, my world is in harmony. Yes, the money part has its ups and downs, but when I put my creative life ahead of business or managing, my life works well.

Painting: Three Ravens

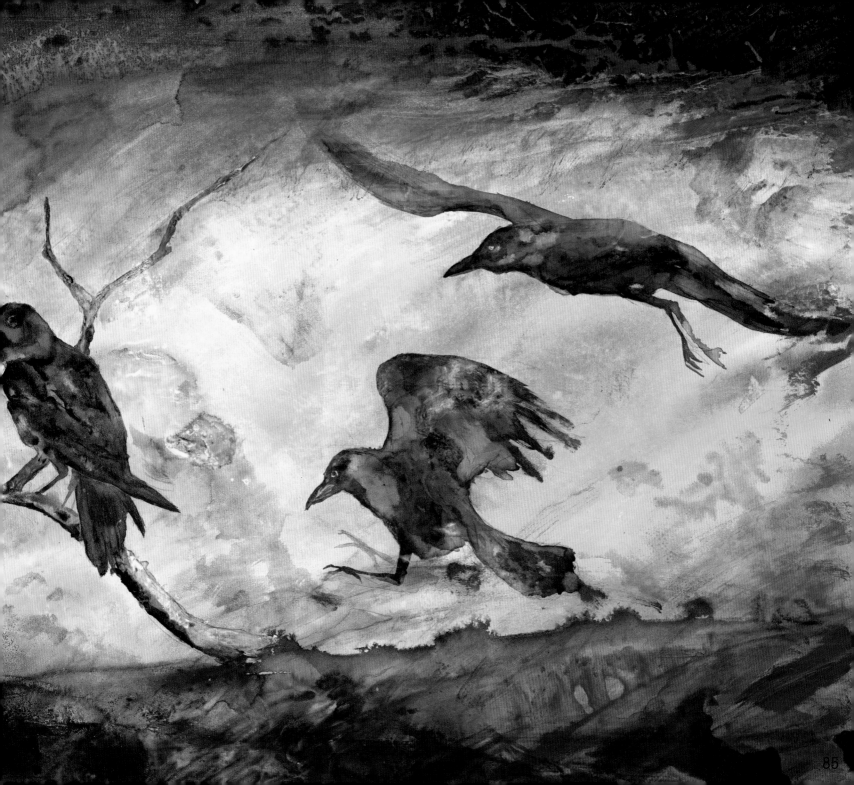

July 22

It is characteristic of artists to be unhappy with their work. After a book is out there, published, nothing can be done to correct its shortcomings. But after a painting is finished, you can sometimes sneak in and change what's been bothering you:

Brassaï writing about Pierre Bonnard in *The Artists of My Life*:

His works, which appear almost to have been improvised, were frequently very slow in getting started and underwent many changes. He often took one or two years to finish a canvas and he would sometimes return to it years later. There is a story of how he once took advantage of a guard's absence from a room in the Musée du Luxembourg to dash over to alter a detail that had bothered him in one of his pictures with some paints and brushes he had concealed in his pockets. He was supposed to have had recourse to the same clandestine maneuver in the Musée de Besancon. According to Antoine Terrasse in his fine book about his great-uncle, the same was true in the case of the *L'Amandier*: "A bit of green on the left side bothered him," Antoine Terrasse wrote, "on the spot where he had already placed his signature. He asked his nephew Charles to help him cover it with a golden yellow."

July 30

Real art is the communication of spirit of the object by the spirit of the artist to the spirit of the viewer.

> Nothing is less real than realism — details are confusing. It is only by selection, by elimination, by emphasis that we get the real meaning of things.
> - Georgia O'Keeffe

I don't necessarily agree with Ms. O'Keeffe, but there's an aspect of what she says that is right on.

I don't think that realism is any less valid as art than is abstract expressionism, or vice-versa. Similarly, I don't think that jazz is superior to classical or rock music. But good art has a power that comes from clarity, from a powerful will, a powerful idea, on the part of the artist. The painting that captures the flying spirit of the bird is much more interesting and compelling than the one that simply gets the feathers right. Often, it seems, the quickly executed, relaxed painting is better at capturing the spirit than is the meticulous image slaved over.

August 6

> I am fifty years old and I have always lived in freedom; let me end my life free; when I am dead let this be said of me: "He belonged to no school, to no church, to no institution, to no academy, least of all to any régime except the régime of liberty."
> - Gustave Courbet (1819–1877)

Gustave Courbet was a painter of "Realist" paintings and an inspirational figure. When ten of his paintings were rejected by a prominent gallery, he created his own gallery next door and exhibited forty of his paintings. His work was widely derided by the public and critics, and sales were poor. One, "The Artist's Studio," depicted his studio with him in the center working on a landscape. Beside him, looking over his shoulder, is a nude model. On one side are friends and supporters, on the other a priest, a prostitute, a grave digger and a merchant who represent what Courbet described in a letter to Champfleury as the "world of trivial life, the people, misery, poverty, wealth, the exploited and the exploiters, the people who live off death." The painting is now regarded as a masterpiece.

One of Courbet's mistakes was getting involved in politics. In 1871, he proposed that a column of cannons erected to honor the military victories of Napoleon be disassembled. In fact, he offered to do the disassembling. A

short while later, the prevailing government of the time had the column removed. Political tides changed, and a new government decided that he, Courbet, was responsible for the column's removal, and sentenced him to six months in prison and a fine of 500 francs. The column was rebuilt, and Courbet was told to cover the cost. Unable to pay, Courbet fled to Switzerland. During this period, the final years of his life, he painted several paintings of fish, hooked and bleeding. He died at the age of 58 of liver disease, probably a result of his escape into alcohol.

September 1

One of the great satisfactions of being an artist is the occasional recognition that somehow, occasionally, one of your paintings captures the spirit, the underlying order, of things. To create a work that captures the divinity of existence is truly satisfying.

September 10

Here you are waitin' to know about cree-a-tivity. Lemme tell you somethin', baby. Ca-rin' is where it's at. Trust me now because I know what I'm talkin' 'bout — you got a love for what you're doin' and everythin'

Painting: Portage Hill

else, all the rest of this cree-a-tivity stuff you're wonderin' `bout, baby, it just comes.
- Ellen Stewart, founder of the La MaMa Experimental Theatre Club and recipient
of a MacArthur "Genius" award from the book *Uncommon Genius* by Denise Shekerjian

September 15

Isaac Bashevis Singer wrote his first novel, *Satan in Goray,* when he was 26. He wrote somewhere over 30 books in total, including children's books and 18 novels. He received the Nobel Prize for Literature in 1978. The following excerpt is from an interview conducted by Stanley Rosner and Lawrence E. Abt and published in the book *The Creative Experience:*

> You have to have a story. A story means there are surprises, where
> the reader does not know when he reads the second chapter what will
> happen in the third chapter. Sometimes even the writer does not know.
> But, this is not enough. The story has somehow to fit my point of view,
> my emotional look at things. I have three rules for writing a story.
> These are my private rules. The first thing is the easiest thing. It has
> to be a story, a real story, what I call a story. In other words, the fact
> that a man got up in the morning and he went to a restaurant, and ate
> breakfast, and he came back home and read a book is not a story for
> me. Although, to some other writers it may be a story. In my case, it
> must be a real story. There must be some surprises as I said before.
> This is number one. I have to have a topic. The second thing is, I have
> to have a passion for this topic. Sometimes I can find a very good topic,
> but I have no desire to write about it. I just feel I can do very well with-
> out this story. And, there are millions of such topics which I have writ-
> ten down, which I thought would be a very good theme. But, somehow
> the desire to write them was not there. But, then there comes a third

condition which is most difficult. Before I sit down to write a story, I must have the conviction that only I can write this particular story, that of all the writers in the world, I am the only one that can write it. When I wrote "Gimpel the Fool," I knew no other writer could write it. He might write a story about a Spanish fool, or an English fool, but to write a story about a Yiddish fool in a little shtetl, and such a particular fool like this one, this is my story. And this is true about every story I write. It has to be my own story. Many writers will get a topic and they will write about something which any other writer, or some other writer could write. When we see the great works in literature, we know that they were all completely unique. Tolstoy was a great writer, but he could never have written *Crime and Punishment*, never, or *The Brothers Karamazov*, or any of Dostoevsky's short stories. Only one man in the whole world, of all times, could have written *Crime and Punishment*. The same thing is true about many writers. When you read, let's say, a certain novel by Faulkner, only Faulkner could have done this. A writer should find what is his story, his particular story, which only one man in this life and all generations can do. I personally believe that every man has such stories to tell even if he's not a writer.

. . . when I wrote *Satan in Goray,* I said to myself, this is my stuff. No other writer could have written it, and until today I somehow have the feeling, at least the illusion (but even the illusion is important) that every one of my stories could have been written only by me.

Lately I write a lot about events which take place in America, in the United States. For example, in my collection of short stories, *The Séance*, I have three stories which take place in America. In my book, *Short Friday,* I have two stories which take place in America. One is called "Alone," which takes place in Miami Beach, and then there is another one called "A Wedding in

Brownsville." In the beginning I was afraid I would never be able to connect my way of feeling with the United States. I feared I would not be able to find any stories which take place in this country, which are unique, which are my stories. But, I have convinced myself that this isn't so. After living many years here, somehow I was able to merge my personality with events which take place in this country. I had a story a few months ago in *Playboy*, which is called "The Lecture," where I described a lecture in Montreal, and again, it's my story.

You just cannot prepare to write a story. You cannot get up in the morning and say to yourself, "I'm going to find a topic." You don't find a topic. Somehow it comes to you. It comes "out of the blue," as you say — yet it doesn't. In "The Lecture," I did go to lecture in Montreal. I could not have described the lecture without having lectured. I couldn't have described the lecture in Montreal without having been in Montreal. I could not have described the trip there, the winter, and how the train stopped in the middle of the night, without having had this experience. But, then I described another experience of how a woman dies in the apartment where I go. This did not happen, but I knew such a woman, and I knew that she died, though she did not die there.

September 20

We may worry about death but what hurts the soul most is to live without tasting the water of its own essence.
 - Rumi

Painting: Autumn Portage

September 30

What do you want them to say about you
when you're gone?
Say I never toed a line,
I went my own sweet way to the last.
- Goethe

Sketch: Owl Woods, Winter Evening